Katrina Exposed

A Photographic Reckoning

STEVEN MAKLANSKY

NEW ORLEANS MUSEUM OF ART

2,000 copies of this book were published in conjunction with the exhibition *Katrina Exposed: A Community of Photographs*, organized by the New Orleans Museum of Art and presented May 20 through September 17, 2006.

Second edition printed July, 2006.

Mark J. Sindler's photographs from the Hurricane Documentary Project are published here courtesy of the Louisiana State Museum.

Library of Congress Control Number: 2006927385
ISBN 978-0-89494-102-3

Designed by Linda Rockefeller
Printed and bound by MPress, Kenner and New Orleans, Louisiana

Front Cover Photo - Jonathan Traviesa
Acknowledgements Photo - Jacqueline Sullivan
Back Cover Photo - Tommy Staub

NEW ORLEANS MUSEUM OF ART
WWW.NOMA.ORG

ACKNOWLEDGEMENTS

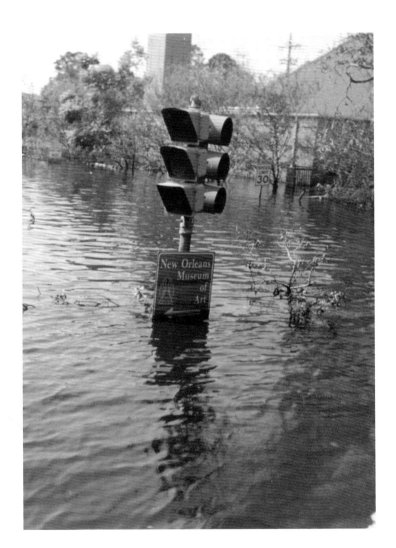

Many Thanks to:

The staff of the New Orleans Museum of Art who are responding to the challenges posed by Katrina with such dedication and resourcefulness.

NOMA's supporters and benefactors.

Linda Rockefeller, Bruce Hirsch, at Mpress who worked tirelessly to design and print this catalog on a heroic schedule.

Many volunteers, but notably Marilyn Davis, Erin Schmaltz, and Aylin.

The Associated Press, Magnum Photos, The New York Times, the Dallas Morning News, The St. Petersburg Times.

All the photographers who participated—and those that did not. A wise fisherman once said "be grateful for the fish in the fryer and don't worry too much about the ones that got away". But please forgive me for not including all the great photographers and photographs that managed to elude my attention.

Everyone in New Orleans for trying so hard, in a town that is no longer the Big Easy. And thanks to you, wherever you are for caring about New Orleans.

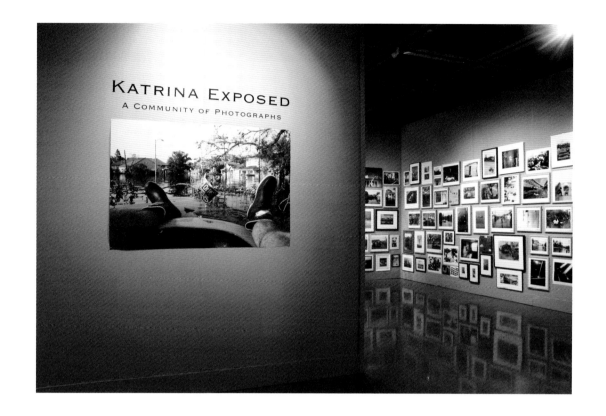

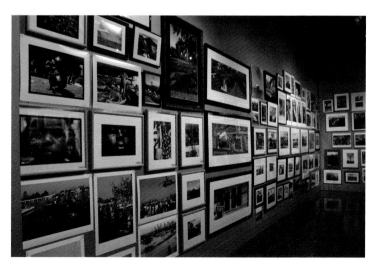

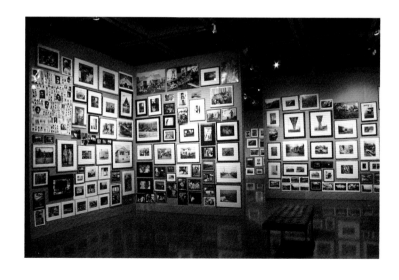

KATRINA EXPOSED: A COMMUNITY OF PHOTOGRAPHS

CONTRIBUTING PHOTOGRAPHERS TO THE EXHIBITION

Alicia N. Neal
Allison J. Gorlin
Alvaro R. Moralez
Andy Levin
Angel Franco
Angelicka Robinson
Antoine Williams
Arne Hook
Ashley Merlin
Audreyanna Franklin
Basi McAshan
Beth Lambert
Bill Haber
Bill Porche
Brian Sands
Brian Gauvin
Carrie Massey
Casey Coleman
Cecil Rimes
Celeste Marshall
Charlie Varley
Chicory Miles
Chris Jordan
Chris E. Mickal
Christopher Robinson
Clara Paletou
Clifton Faust
Connie Alloto
Curtis Marks
Cynthia Scott
D. Favreau
Dave Martin
David Julian
David J. Phillip
David Rodrigue

David Rae Morris
Debra Howell
Dennis Formento
Dennis Couvillion
Donna Hurt
Douglas R. Clifford
E.J. Goldstein
Edgar M.S. Jimenez
Elizabeth Kleinveld
Ellis Joubert III
Eric Gay
Erica Jackson
Erica Mire
Ernest Johnson
Esther Murphy
Eugenia Uhl
Frank Relle
Gabriella Mills
George Long
Heather Weathers
Helen Nardell
Hope Crockett
Iain Baird
Ian J. Cohn
Irwin Tompson
Jackson Hill
Jan Gilbert
Jan Munson
Jane Alt
Janice L. Kazmier
Jean Manale
Jeffrey J. Thomas
Jennifer Shaw
Jessica Goldfinch
Jim Lommasson

John Datri
John Thornton
Jonas Austin, Jr.
Jonathan Traviesa
Joseph C. Kerkman
Josephine Sacabo
Joshua Mann Pailet
Judi Bottoni
Judy Cooper
Juli Bottoni
Julie Elise Ledet
Katelyn Atkinson
Kathy Anderson
Kathy Cacioppo
Kay R. Byrd
Kevin Nardell
Kim Bergeron
Krista Jurisich
Laurie Manley
Lawrence Williams
Lee Area
Leo McGovern
Leslie Claire-Spillman
Leslie Killian
Leslie Parr
Leslie T. Snadowsky
Libby Nevinger
Lori Waselchak
Louviere + Vanessa
Lynn Davis
Malcolm McClay
Mandy Conger
Manford Pollard
Mark J. Sindler
Marianna Day Massey

Marsha Ercegovic
Mary Laigast
Mary Lambert
Mary Perrin
Melinda L. Shelton
Melisse Campbell
Meryt Harding
Michael Fedor
Michael Higgins
Michael Smith
Michel Varisco
Michelle L. Elmore
Mike Goodwin
Nancy L. Staub
Nathan Kern
Nicole Marie Roché
Owen Murphy
Paolo Pellegrin
Pat Cassidy
Paolo Pellegrin
Patricia K. Ammon
Patricia Sills
Patricia Hart
Patrick M. Burke
Paul Wood
Peter Devine
Raymond Robinson
Rebecca Boehm
Reggie Scanlan
Renee E. Allie
Richard McCloskey, Jr.
Rick Bowmer
Rita Posselt
Robert Robinson
Roni Casale

Rose Gilliam
Russell Christie
Sandra Burshell
Sarah Whalen
Scott Saltzman
Sethasak Boonchai
Shannon Brinkman
Srdjan Loncar
Stewart Harvey
Stewart Johnson
Suzanne Sheridan
Suzanne Vicknair
Sylvia Schmidt
Tabitha Soren
Tatyana Franklin
Tawanee Green
Taylor Desormeaux
Taylor Mackles
Terrence Sanders
Thom Bennett
Thomas Dworzak
Tina Freeman
Tom Varisco
Tommy Staub
Tony Watts
Vadal Jackson
V.L. Sanders
Vanessa Sanborn
Victoria Ryan
Vincent LaForet
West Freeman
Wyatt Gallery
Ze daLuz

KATRINA EXPOSED

A PHOTOGRAPHIC RECKONING

We saw it with our own eyes.

Every New Orleanian has some visual recollection of Hurricane Katrina; its coming, its arrival, its aftermath, the destruction, the desolation, and now the recovery and rebuilding processes. Now the water has long receded, much debris has been cleared away, and like the distinctive flood lines that mark so many homes and businesses, memories of those fateful days are slowly starting to fade. But forgetting the past is no way to prepare for the future. The challenge, instead, is to remember what is important, to select significance, and keep it safe for reconsideration and review. That is why so many New Orleanians, and some intrepid photojournalists, came through the calamity carrying a camera. Like plucking a struggling victim of circumstance from the deluge, taking a picture is a rescue—a way of preserving a little rectangle of history from oblivion. Stored in an envelope or in a computer, any such image is but a single, personal, and invisible piece of evidence. But if hundreds of such photographs, representing many different and unique viewpoints of the Katrina experience are resuscitated for an exhibition, then they reemerge into a meaningful new arena of public consciousness and contemplation. That is why on behalf of the New Orleans Museum of Art, I asked my community to share their photos.

From New Orleans and its vicinity, more than one hundred people with various backgrounds and motivations, including children who had never before played with a camera, homeowners who were probably thinking more about insurance adjusters than museum curators when they made their photographs, artists who were trying to make sense of their new reality, and local professional photographers who are now getting more than the usual amount of inquiries from national media outlets, contributed a total of almost 700 photographs to the exhibition. As the intention of this project was not to be a typical juried art contest, but rather to offer an inclusive and democratic opportunity for people to share their Katrina experiences, all of their images—a community of photographs—are included in the exhibition.

These are insiders' views, produced by people whose lives have been deeply affected by Katrina. A few never left the city and used their cameras to witness the deluge, while they were helping to rescue people from it. But many of the photographers whose work is represented in the exhibition and this accompanying catalog, had evacuated the city prior to the storm's landfall, and would not—could not—come back until weeks or even months had elapsed. So many days and nights to wonder and fret, to imagine with dread what was waiting for us upon our return. We armed ourselves for the trip back with boots, dust-masks, flashlights, bleach, bottled water, canned food, and a camera. Seeing the destruction and desolation was one thing, but taking photographs made believing it—and eventually confronting and responding to it—more of a possibility. What we see in many of these photographs is thus not so much reportage, as reckoning—a snapshot of reality, acceptance, and insight. What we encounter is human desperation—not only the usual sort that comes with catastrophe, but also a more inspiring desperate need: to find meaning, hope, and even beauty amidst the destruction.

Presented almost nine months after the storm, the photographs in *Katrina Exposed* are also too late to be regarded simply as news. Too much time has passed since the people here pictured were engulfed within such cruel and unusual circumstances, since the events here documented were so excruciatingly current, and since the stunning and sorry spectacle of our city and our homes dissolving in water and mayhem was something we had never witnessed before. In those first few days and weeks it was mostly videography, not photography that was telling the story. The television screen was the little sadistic portal for anyone who cared about New Orleans and its people. It was so hard to watch, but impossible to turn off.

We kept switching from network to network as if hoping to learn that it was all a mistake—that it hadn't really happened, or conversely seeking new or more definitive confirmation of the tragedy from different cameras on different helicopters. From those aerial vantage points the footage was aloft and inevitably aloof; a perception exacerbated by the narration provided by national news anchors who were earnest, occasionally outraged, but short on local knowledge. Video coverage of a news occurrence like Katrina also strives to be nothing less than instantaneous. In its purest form it is broadcast "live" so that we witness the events that play out in front of the camera transfixed by their immediacy. Photographs of news events come just a tiny bit later, and command our attention for different reasons. While the video image is inherently ephemeral, having replaced what came last and being replaced by what comes next in a seamless sequence, the photograph aspires for permanence; a single image extracted and captured from the continuity of visual experience. We couldn't tear ourselves away from the video coverage of Katrina and its aftermath because we were afraid that we might miss something. We return over and over again to the photographs because they did not.

Surely the ability of photographs to record and encapsulate a scene or event for further and future review was part of the motivation of the photojournalists who labored to get to New Orleans while most people were trying just as hard to get away. *Katrina Exposed* includes some outstanding works by these outsiders. Their images were indeed news at the time and will likely reappear in newspapers, magazines, and other publications which seek to retell the story of the storm. But like all of the photographs in the exhibition and catalog, they are here presented without captions or even titles. Just the photographer's name is given, a reminder that these are personal photographic reckonings - images made by someone, not just images of something. The intention is to free these powerful and memorable images from their original burden of specific documentation. We are accustomed to seeing pictures like these surrounded and explained by the text. But this time they hang naked (many without even a frame) on gallery walls, and float unchaperoned on the page. In other contexts (i.e. the newspaper or the courtroom) being told on what street or on what date a dead body was originally photographed might be entirely significant, but in this case you are invited to contemplate and decipher the broader resonance and relevance (and beauty!?) of the image itself.

Besides, if it's too late to see these photographs strictly as news, it's too early to simply consider them as part of the historical record. Not enough time has passed since what we see in these pages can be regarded from the safe distance sometimes referred to as detachment. Nope. It's been

nine months, and its only two weeks before the next hurricane season begins, and we're still in it; New Orleanians are still living through Katrina. Many of our homes, our jobs, and our friends are gone, and our conversations inevitably turn to topics such as government regulations, coastal restoration, contractor's reputations, and neighborhood revitalization. We have not yet reached the point in our actively contested future when tragedy seems outweighed by opportunity. And there may never be a time when looking at these photographs will seem like an analytical, rather than an emotional experience.

Steven Maklansky
Assistant Director for Art
Curator of Photographs
New Orleans Museum of Art

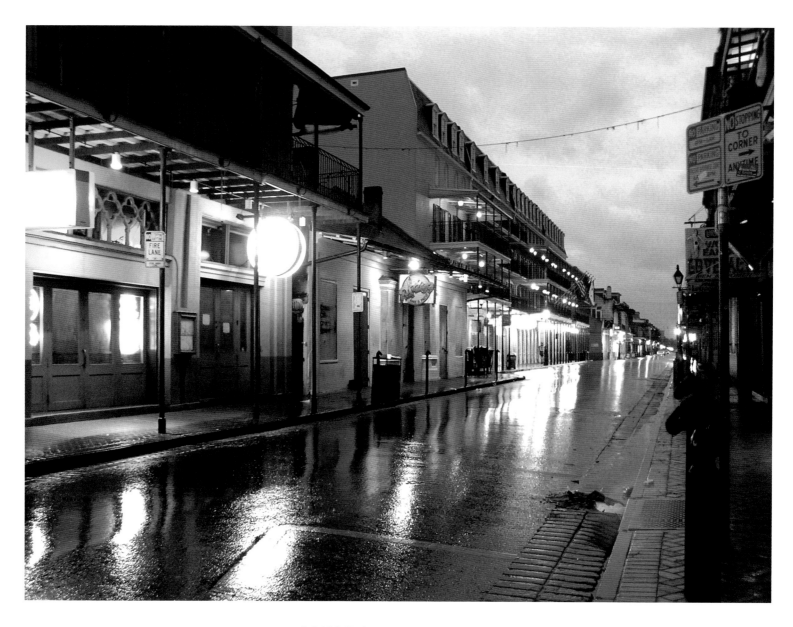

ALVARO R. MORALES

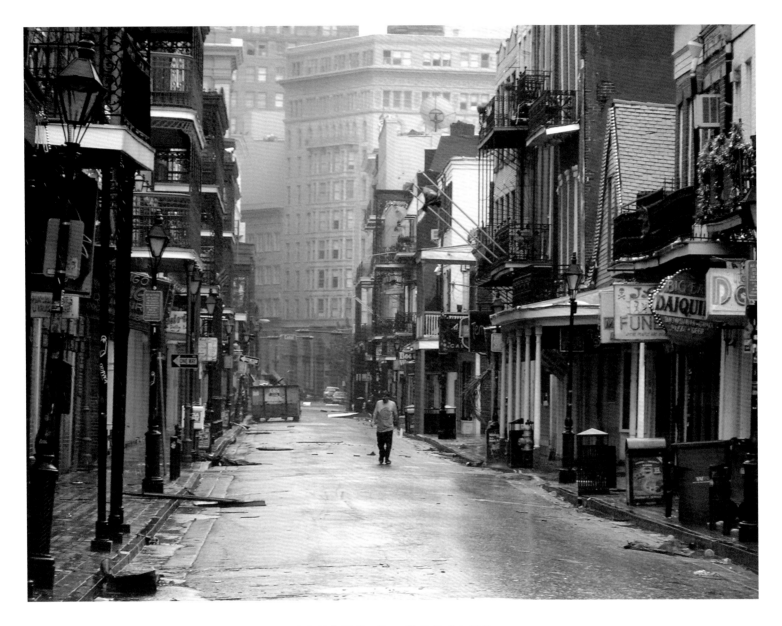

ALVARO R. MORALES

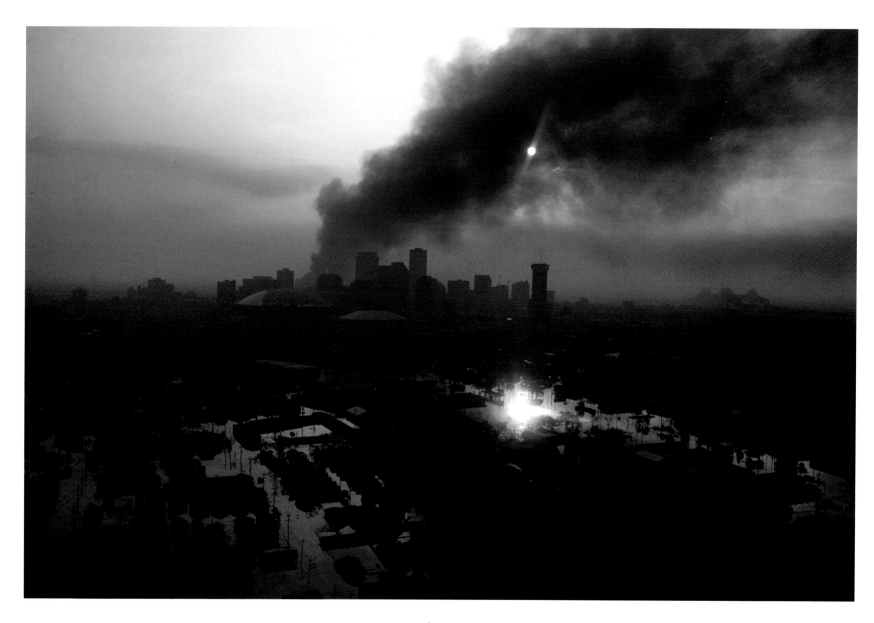

© VINCENT LaFORET | THE NEW YORK TIMES

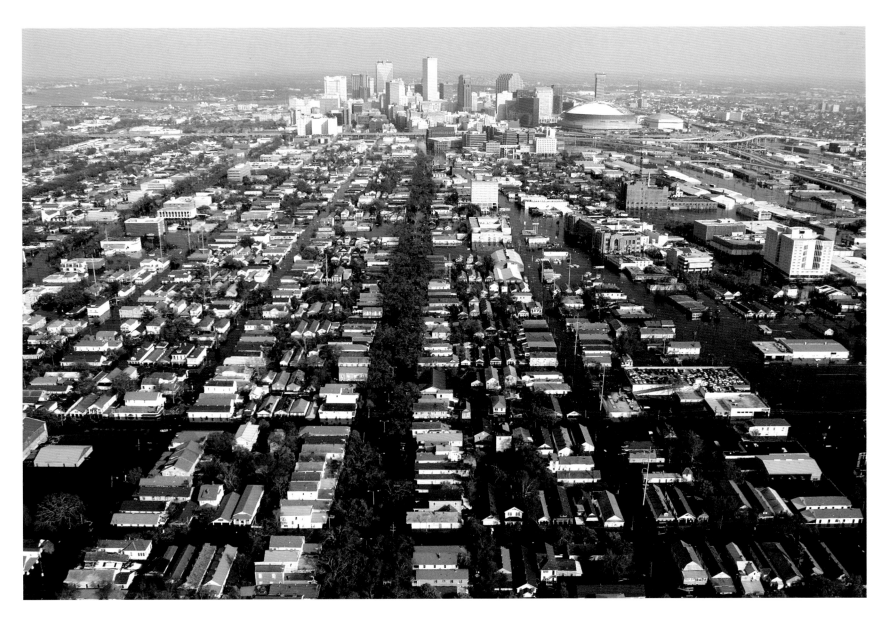

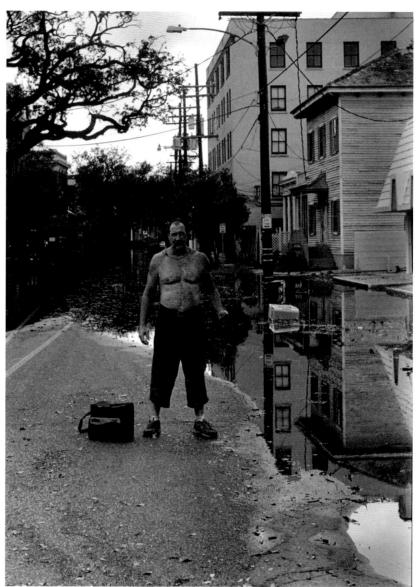

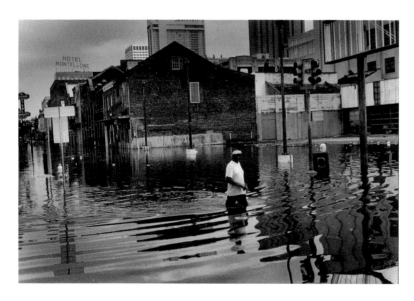

JOSHUA MANN PAILET

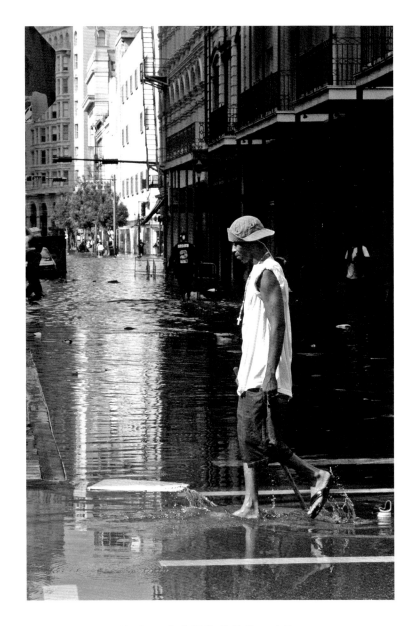

V.L. SANDERS, JR.

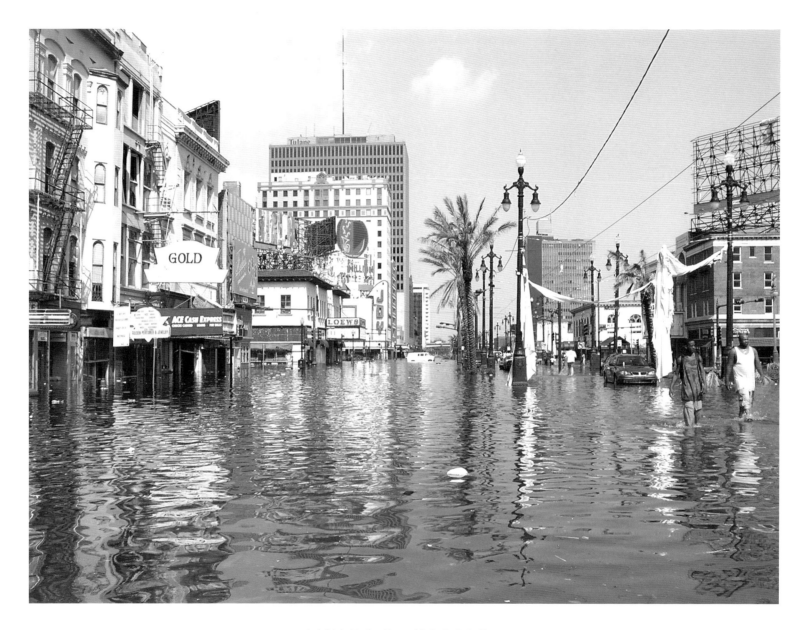

ALVARO R. MORALES

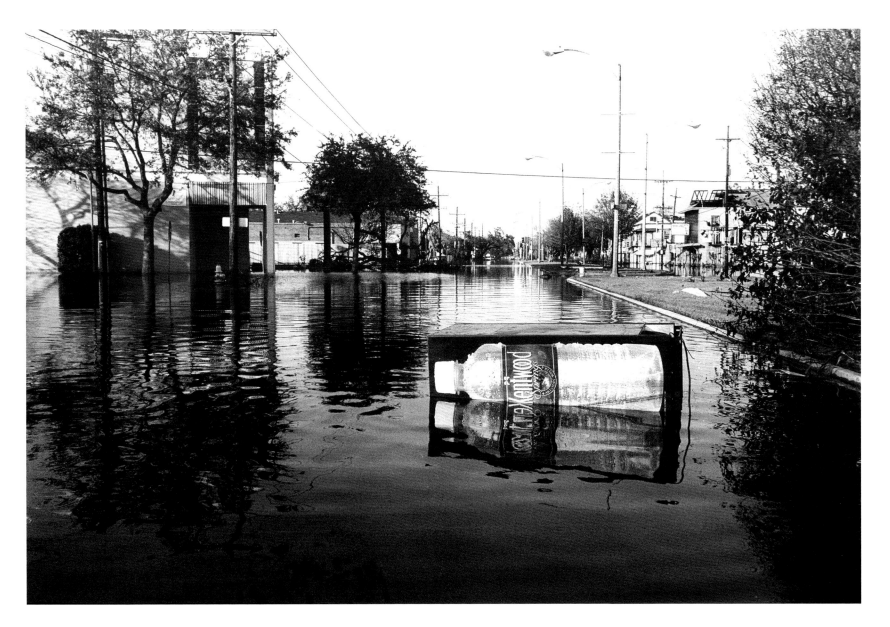

ANDY LEVIN

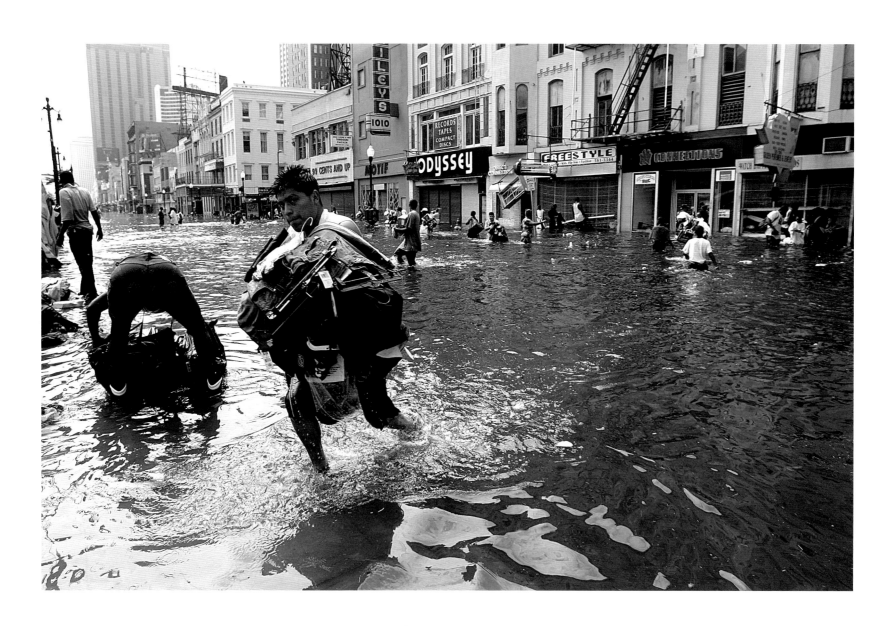

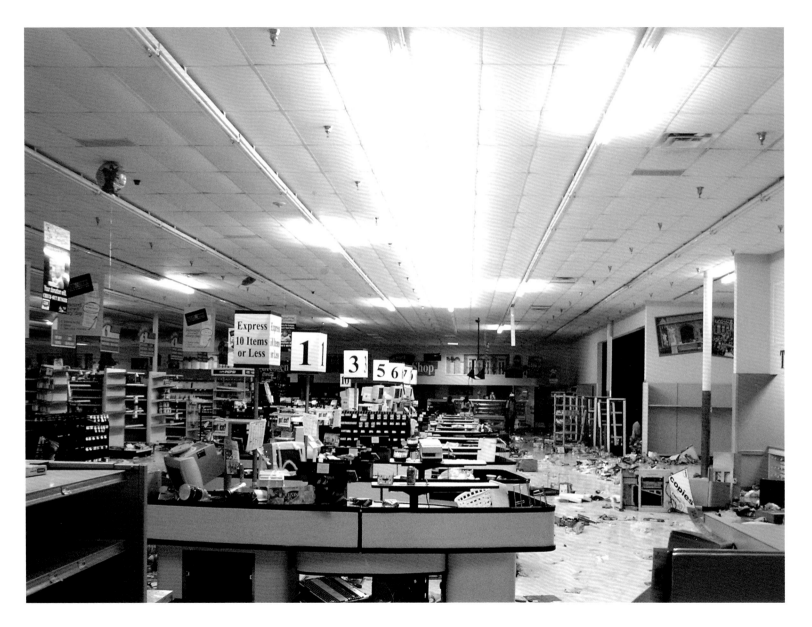

ALVARO R. MORALES

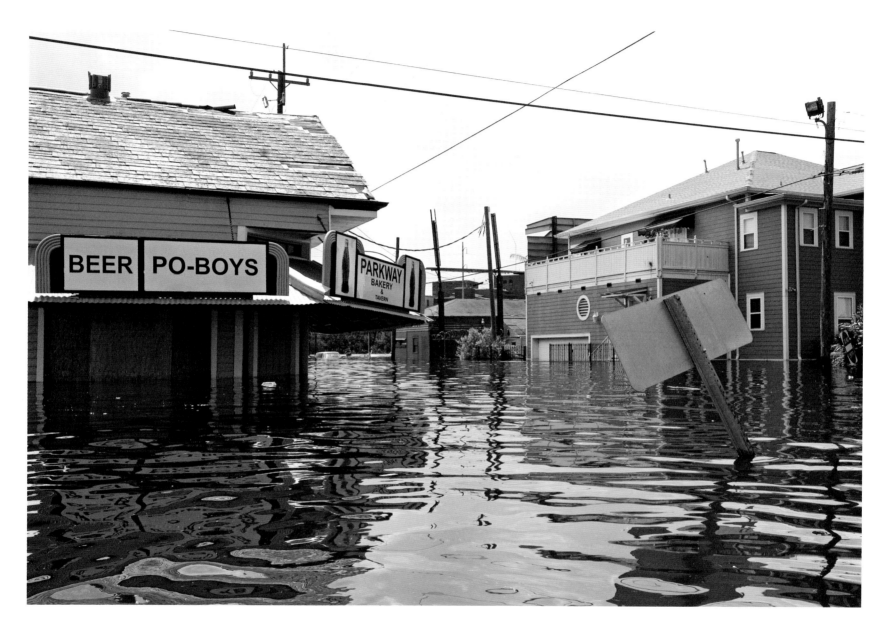

JONATHAN TRAVIESA

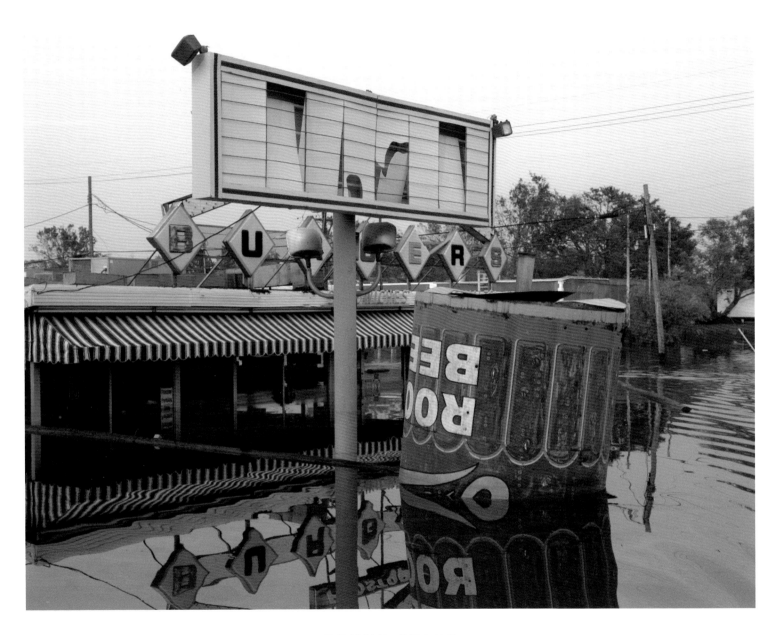

TOMMY STAUB

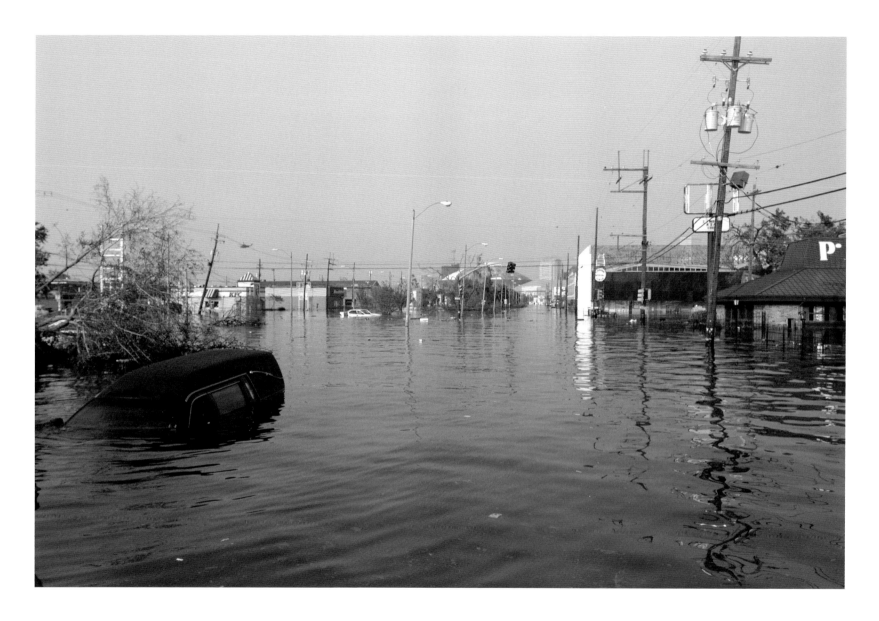

TOMMY STAUB

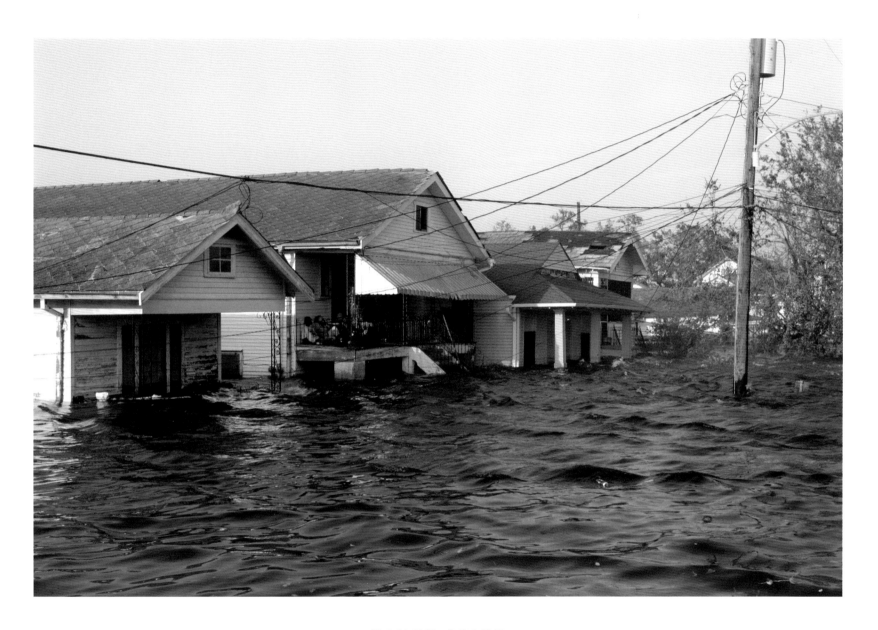

TOMMY STAUB

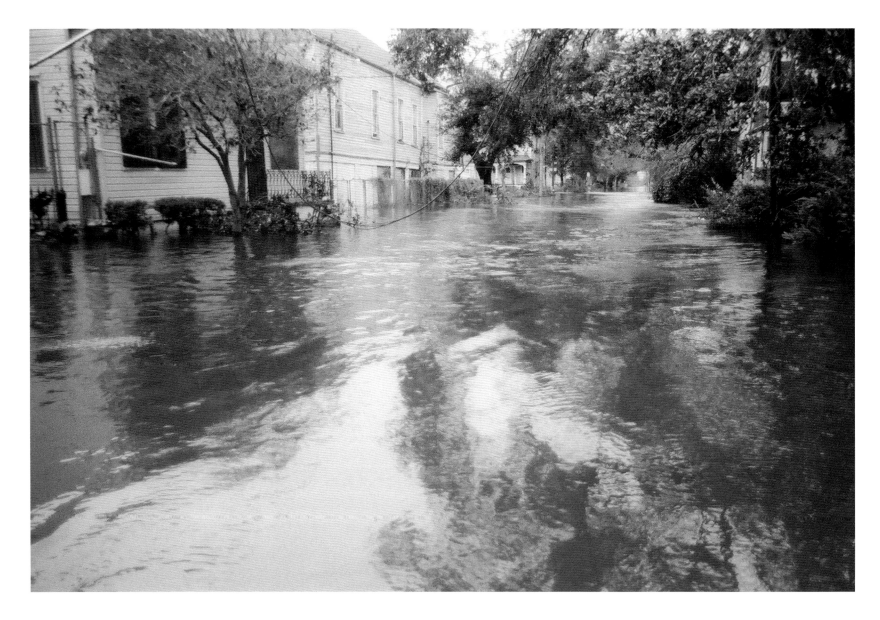

EDGAR M. SIERRA JIMENEZ

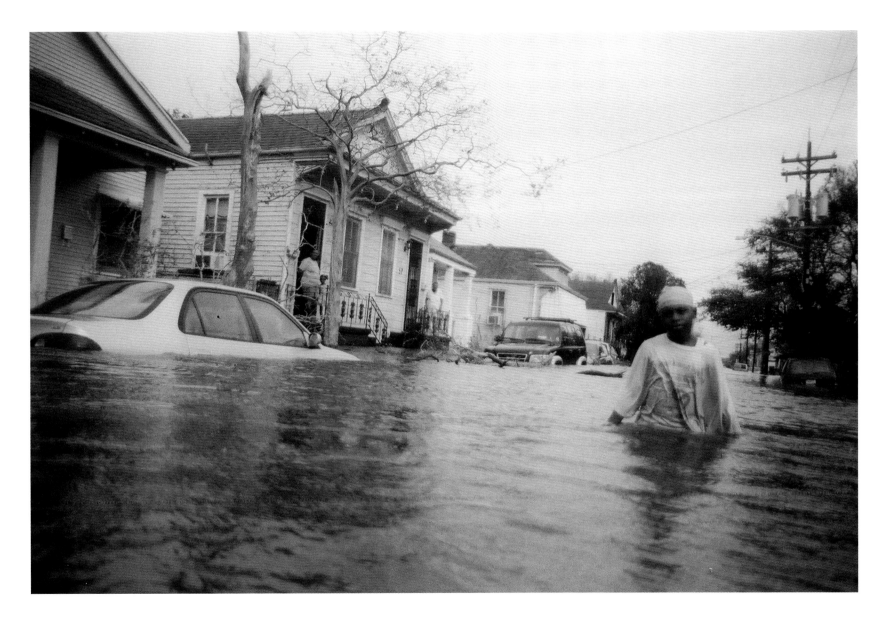

EDGAR M. SIERRA JIMENEZ

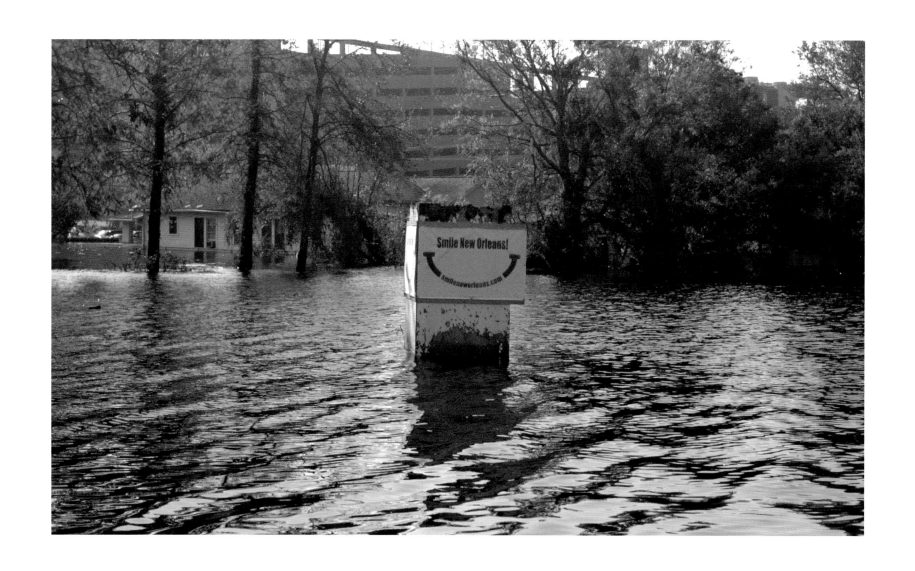

TOMMY STAUB

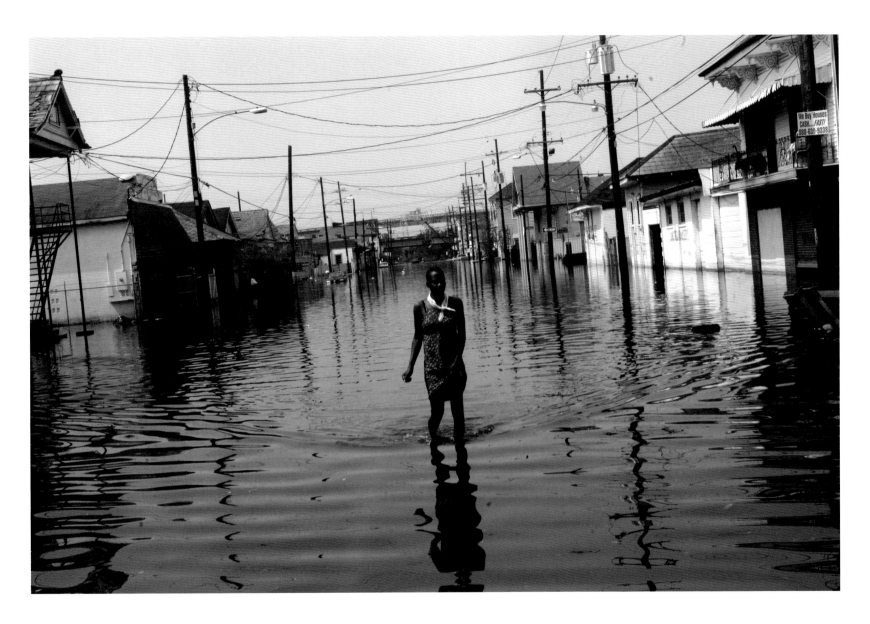

© THOMAS DWORZAK | MAGNUM PHOTOS

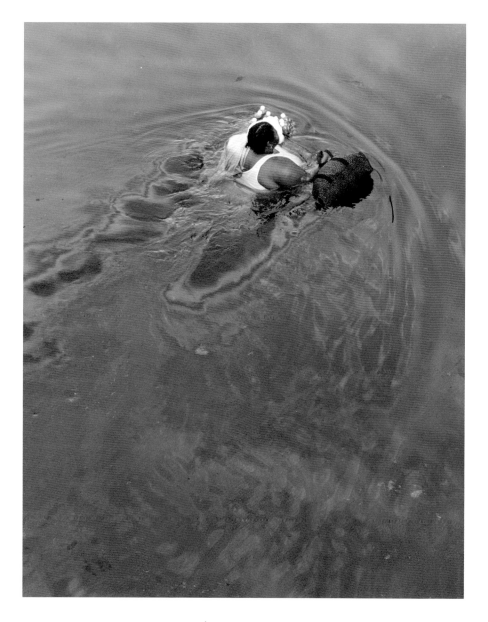

BILL HABER | ASSOCIATED PRESS

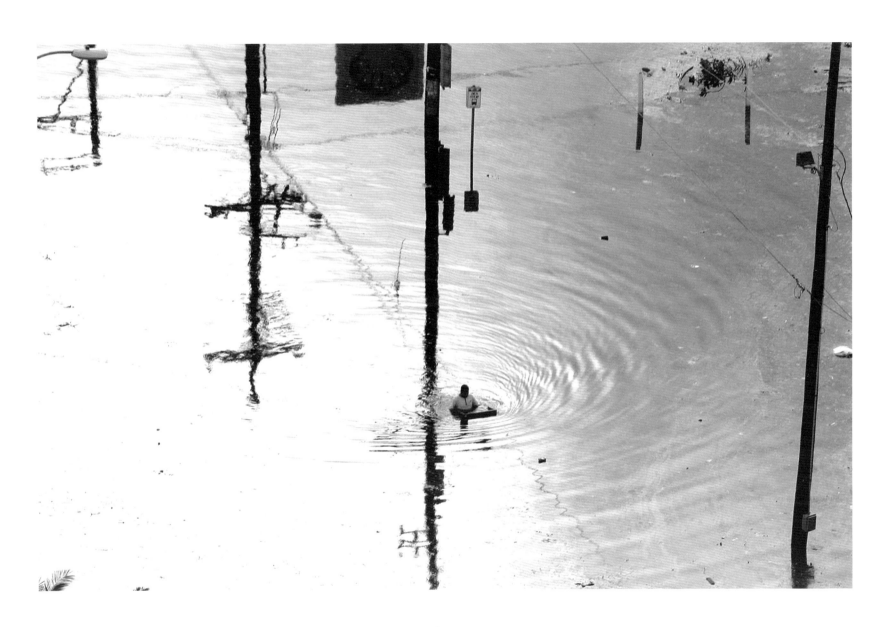

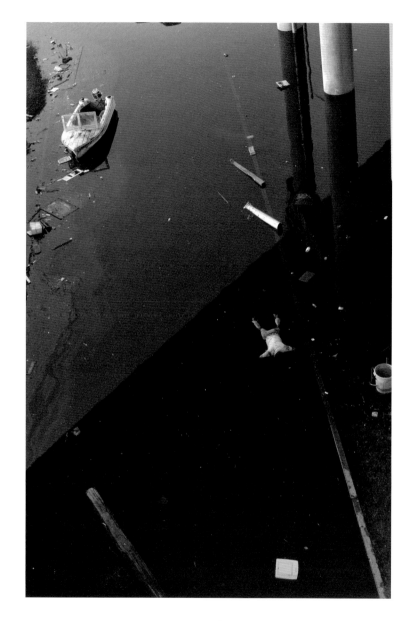

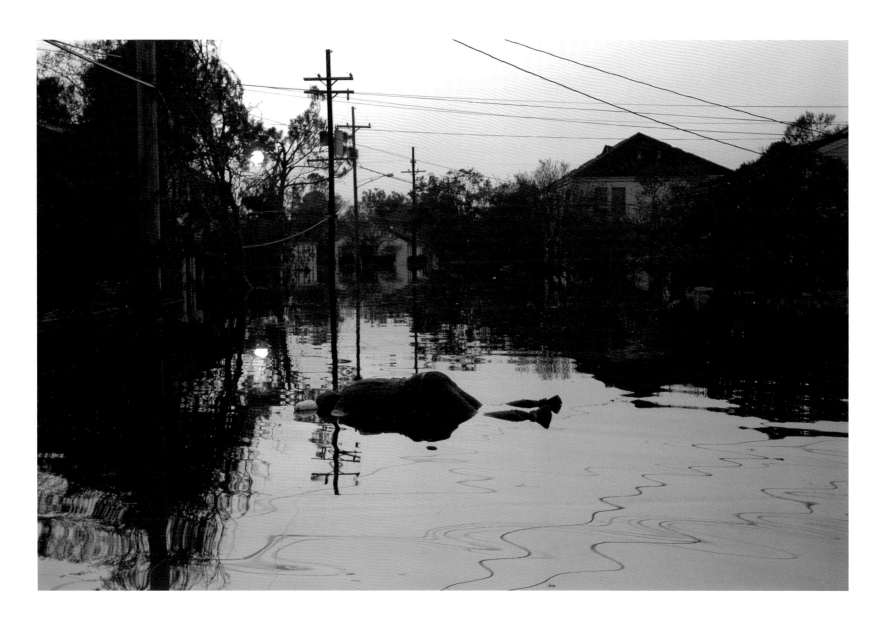

TOMMY STAUB

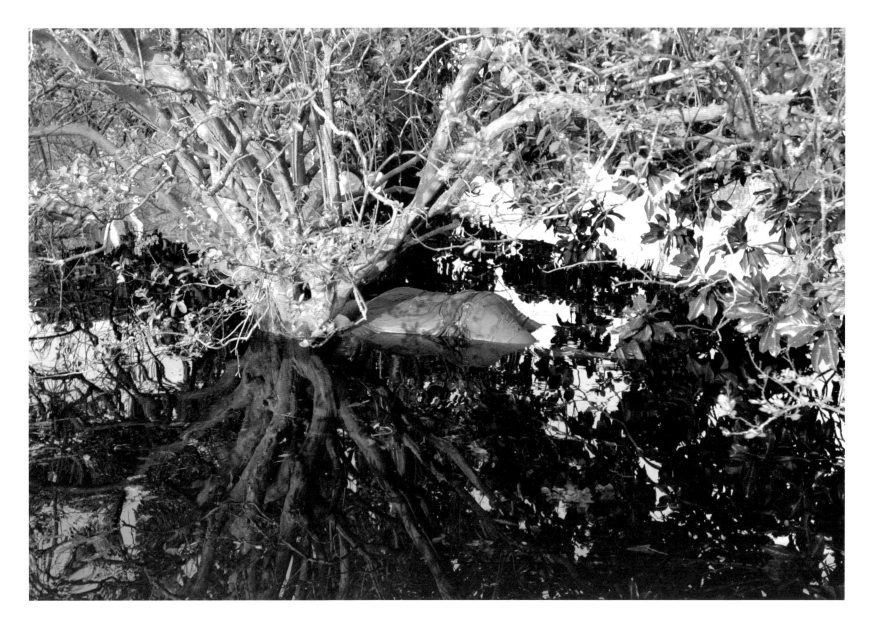

TOMMY STAUB

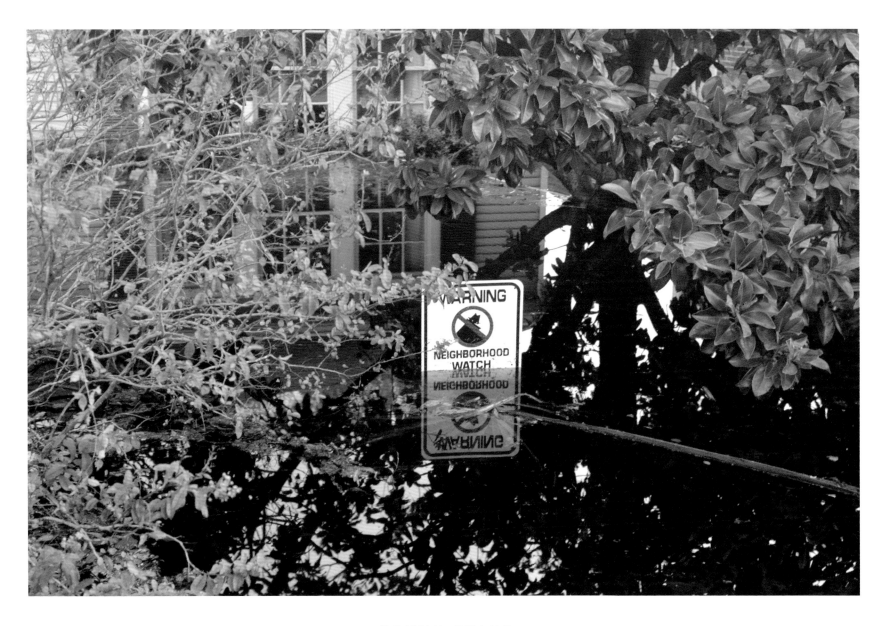

TOMMY STAUB

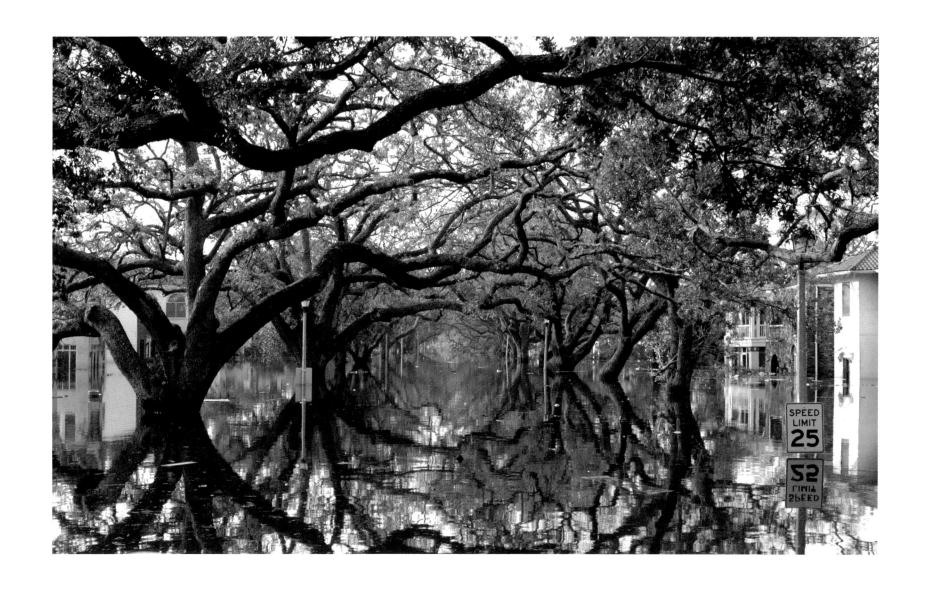

TOMMY STAUB

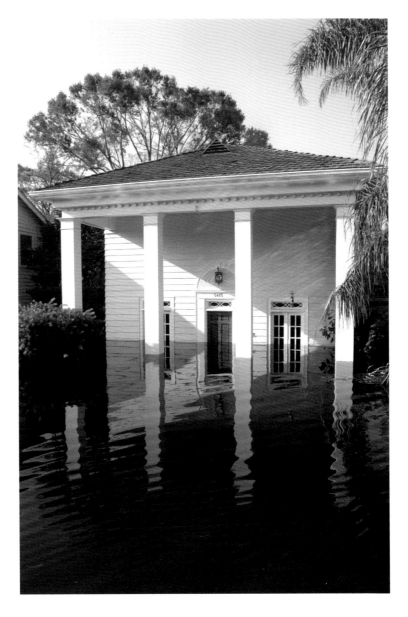

TOMMY STAUB

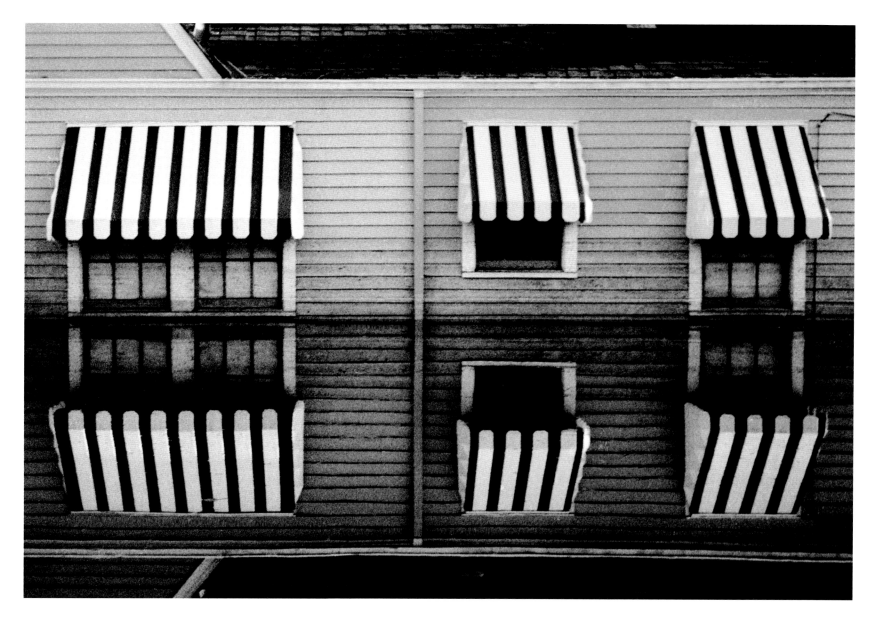

DENNIS COUVILLION

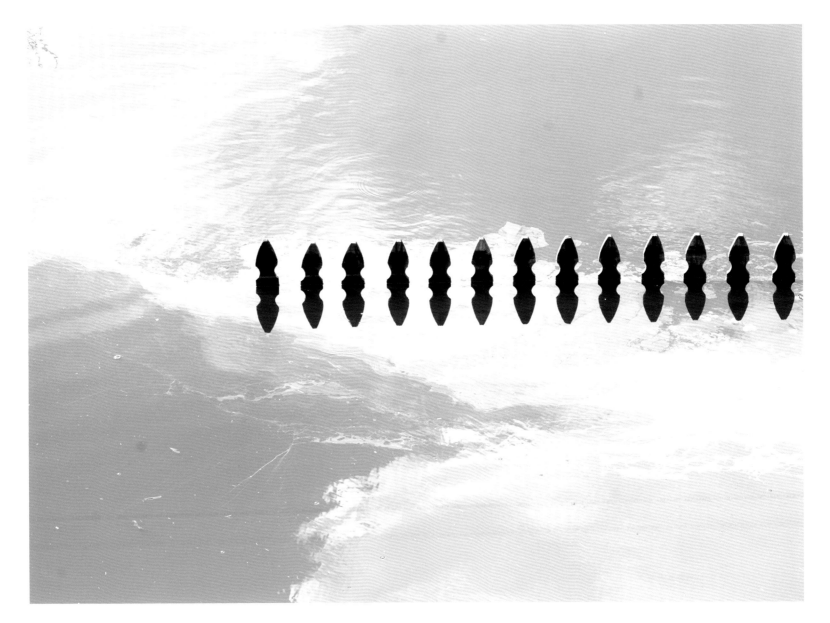

DAVID RAE MORRIS

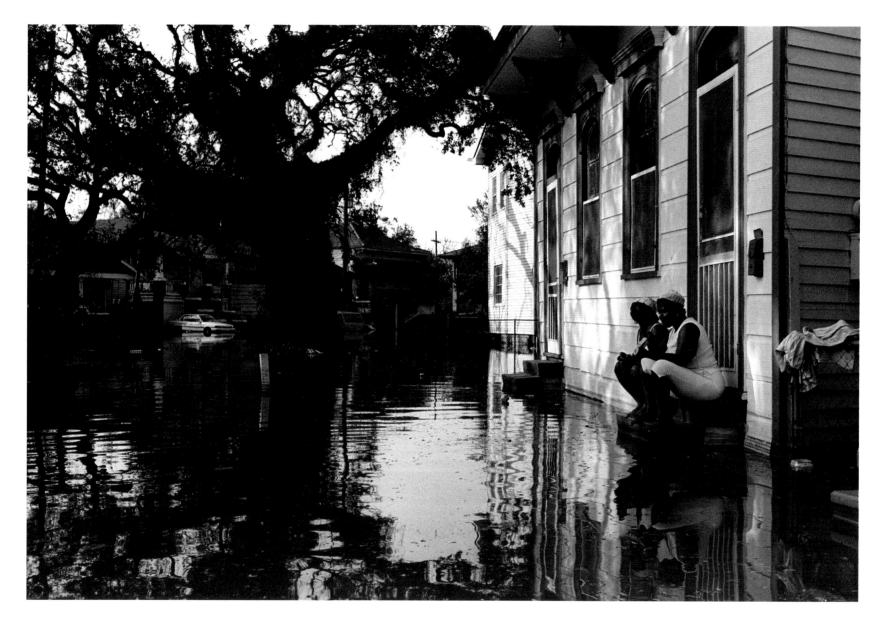

ANDY LEVIN

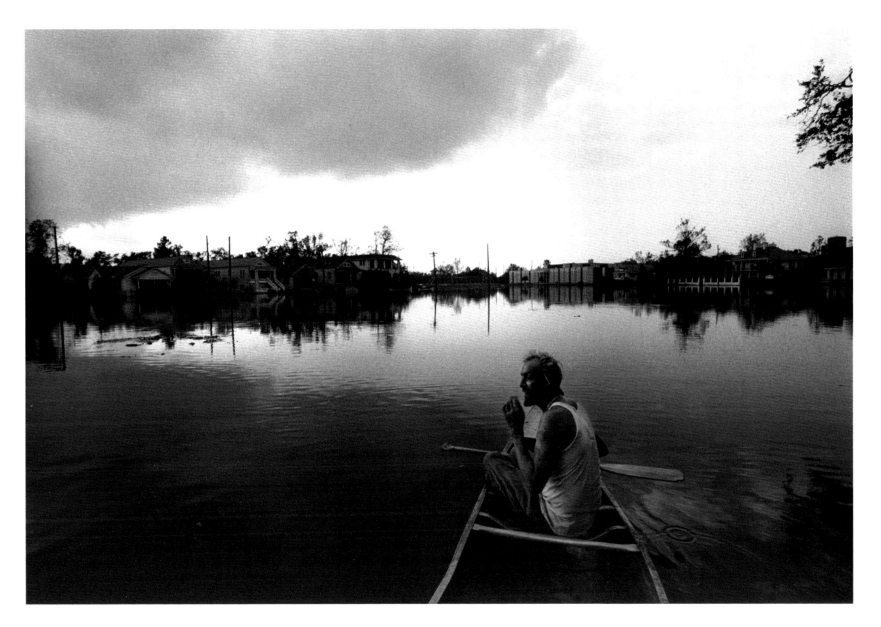

ANDY LEVIN

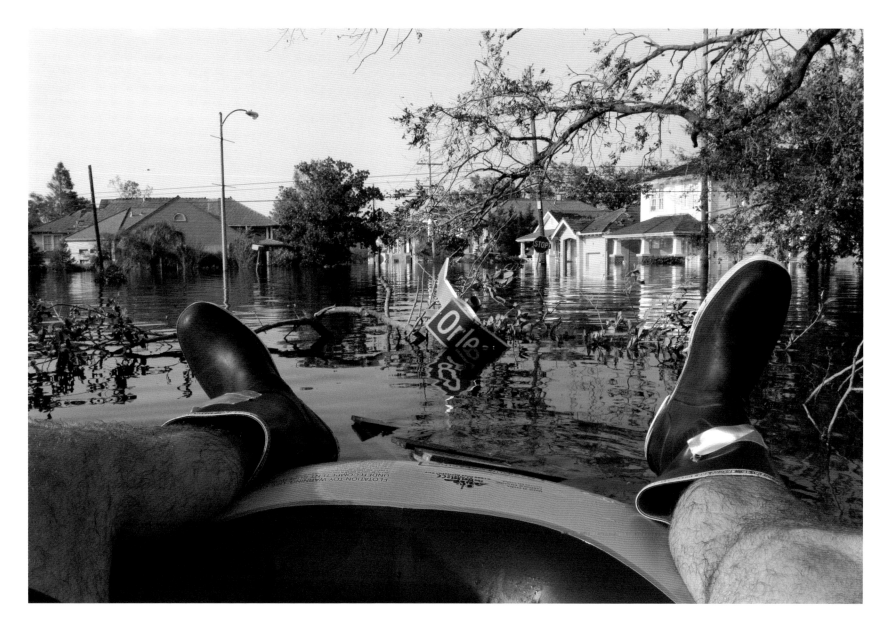

JONATHAN TRAVIESA

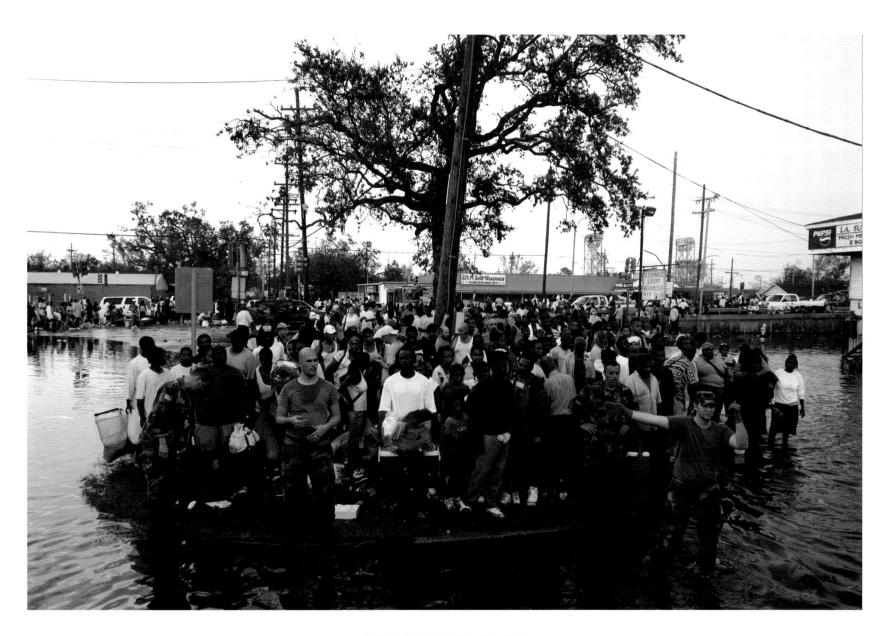

CHARLIE VARLEY

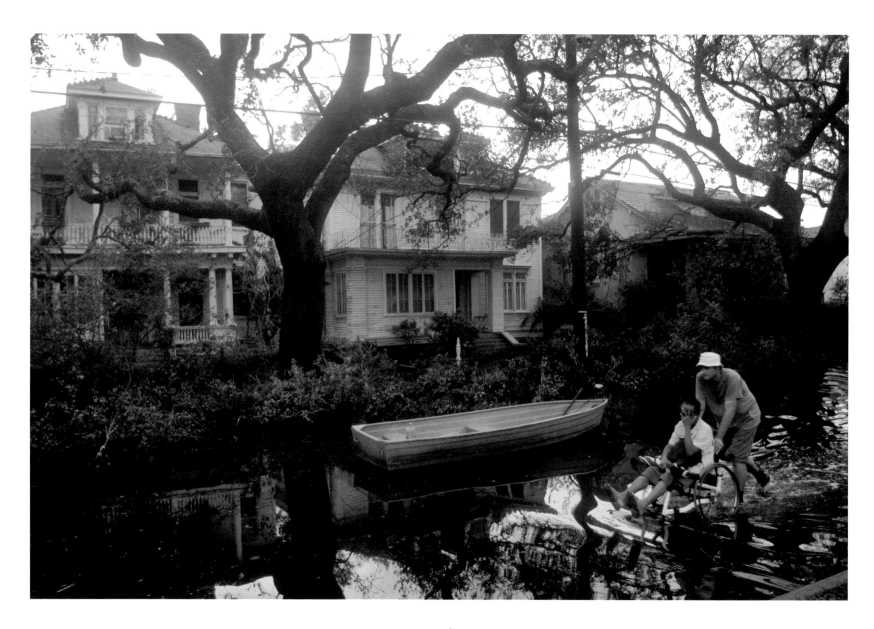

© THOMAS DWORZAK | MAGNUM PHOTOS

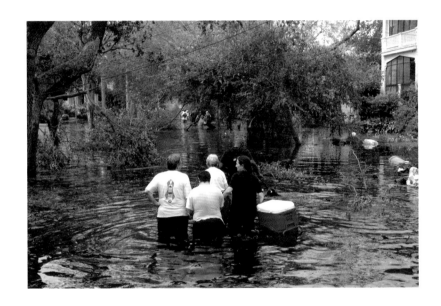 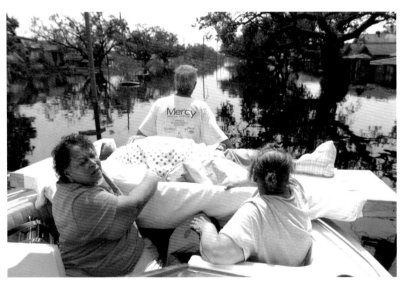

TOMMY STAUB

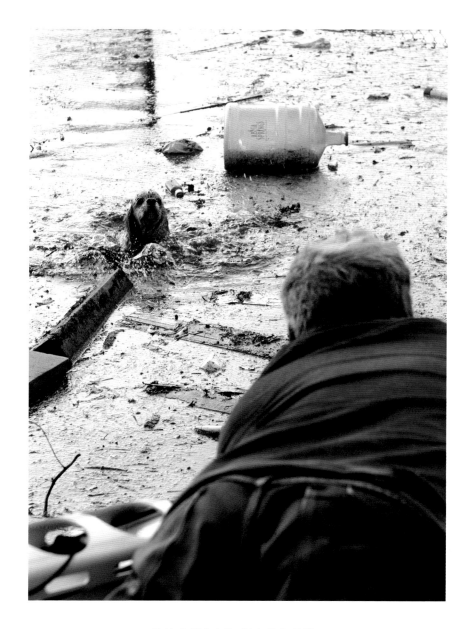

CHARLIE VARLEY

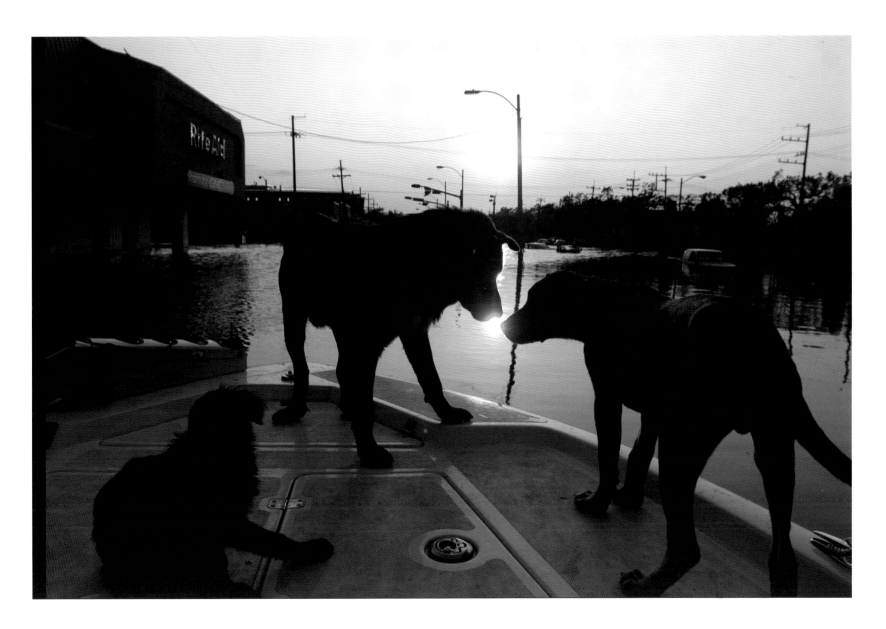

CHARLIE VARLEY

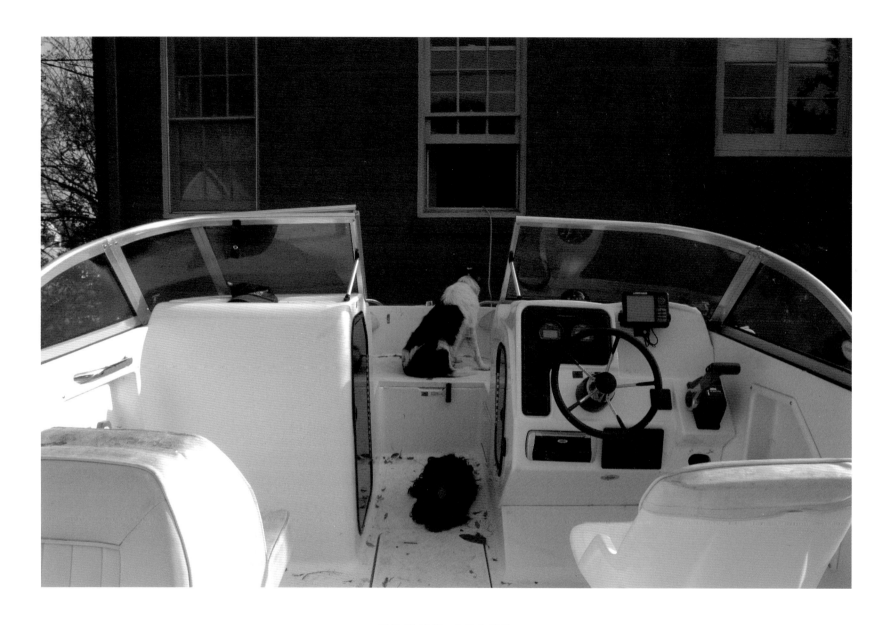

TOMMY STAUB

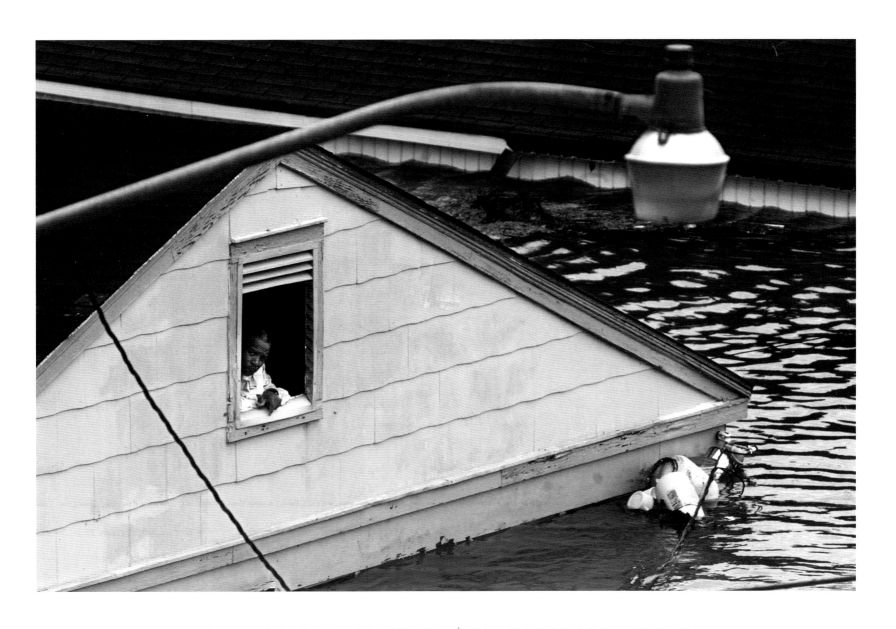

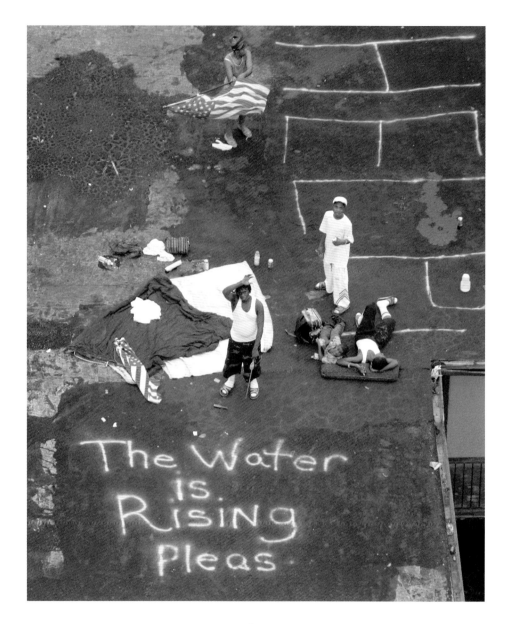

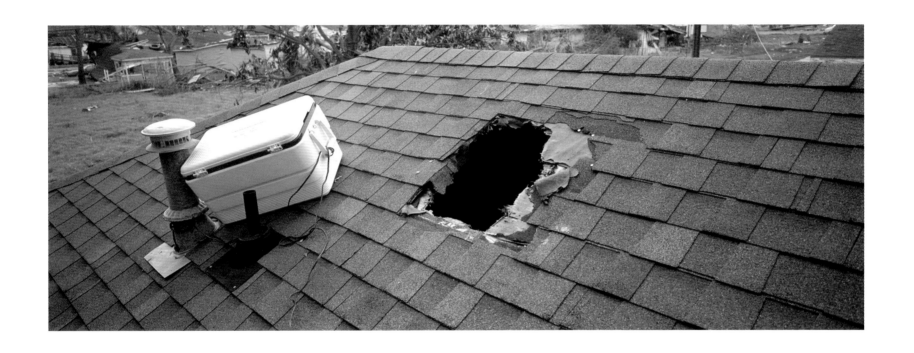

LORI WASELCHUK

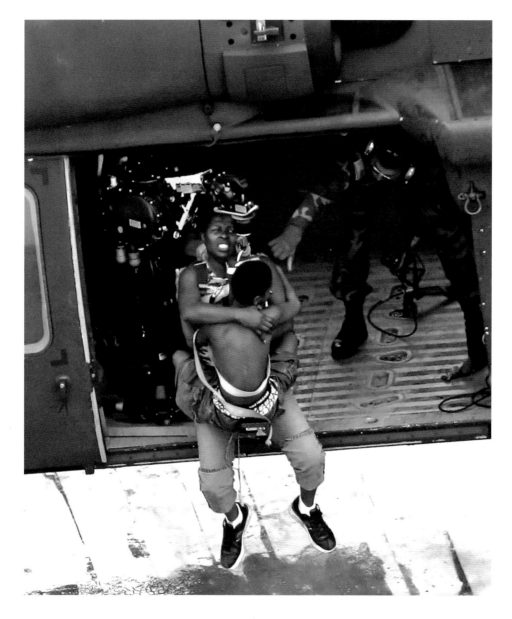

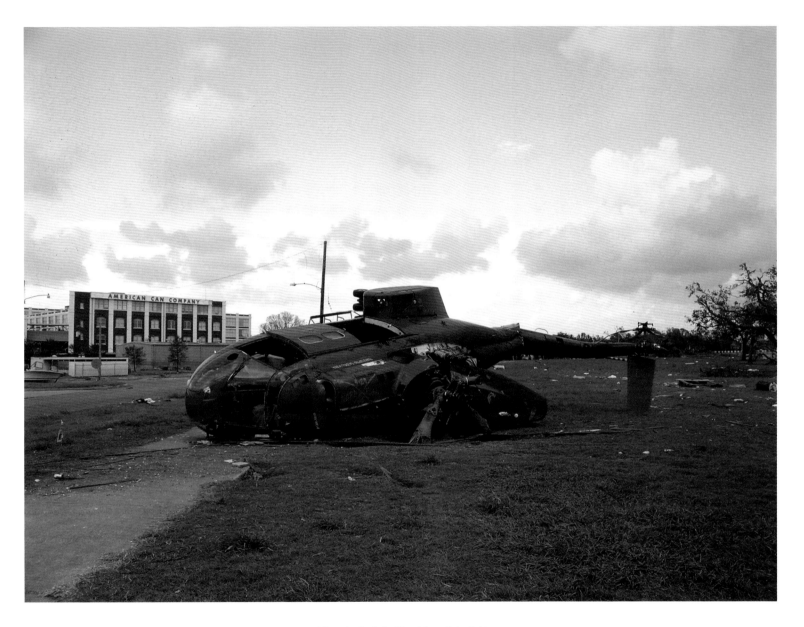

MALCOLM McCLAY

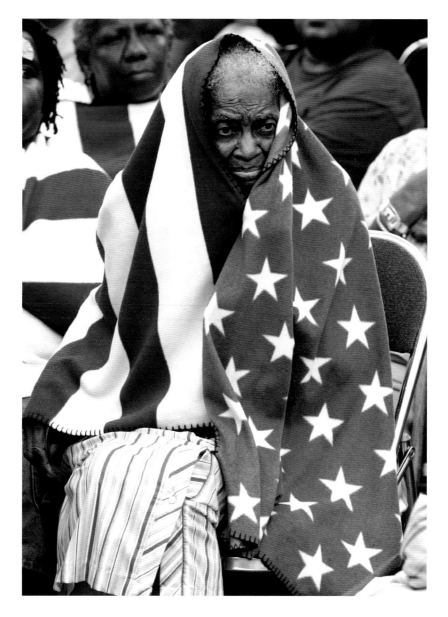

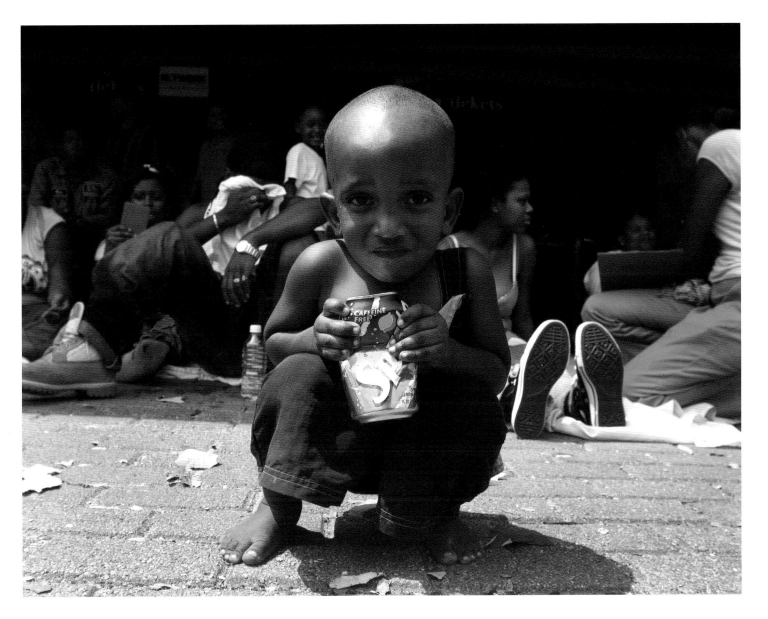

CHARLIE VARLEY

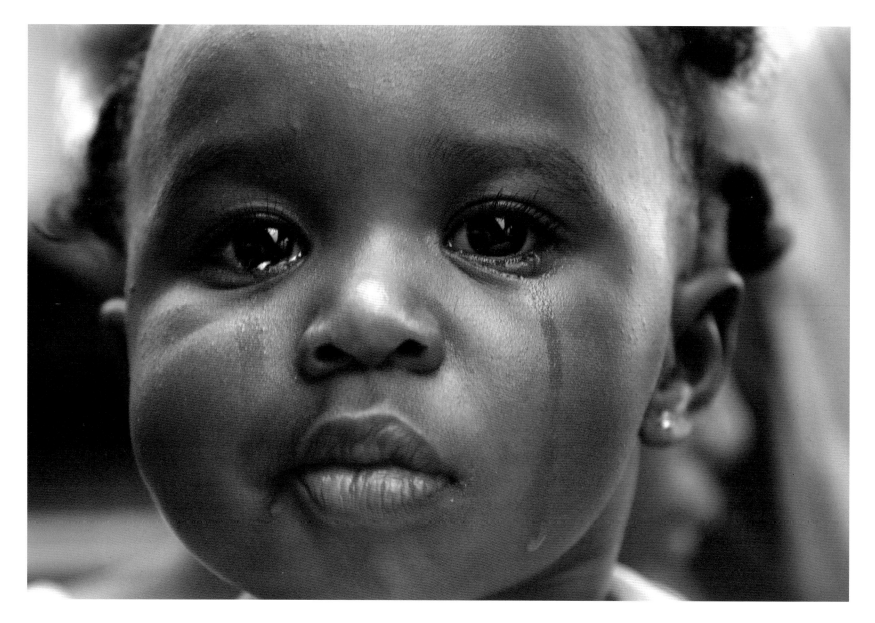

CHARLIE VARLEY

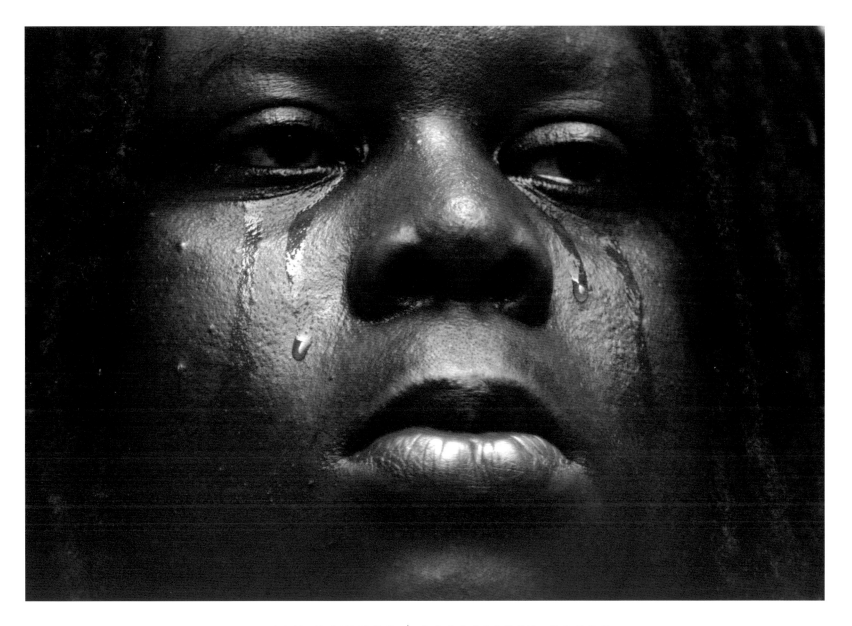

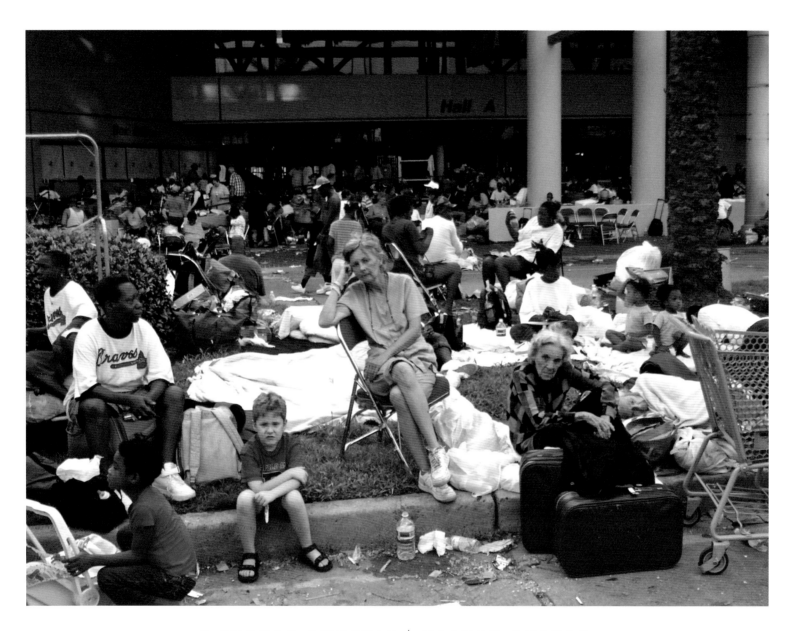

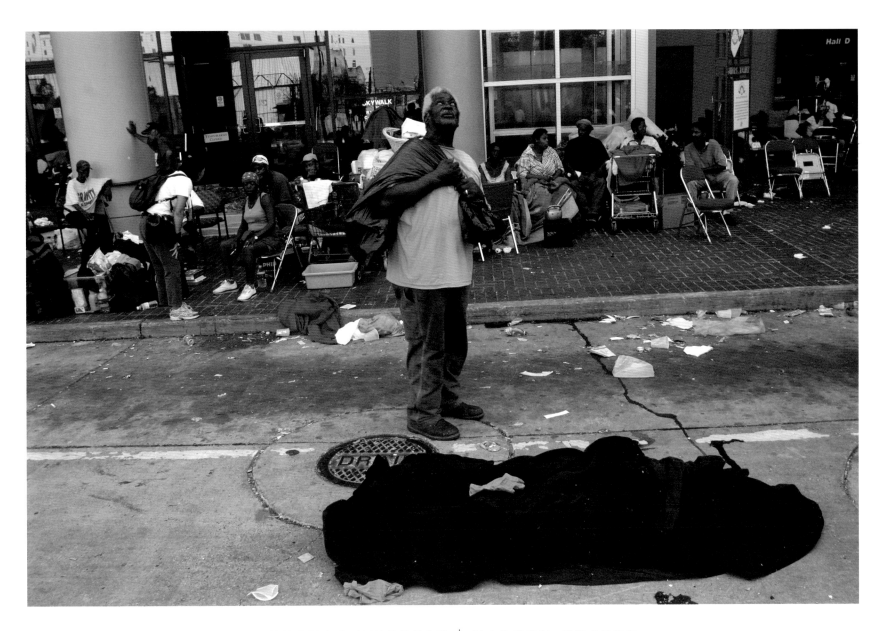

© THOMAS DWORZAK | MAGNUM PHOTOS

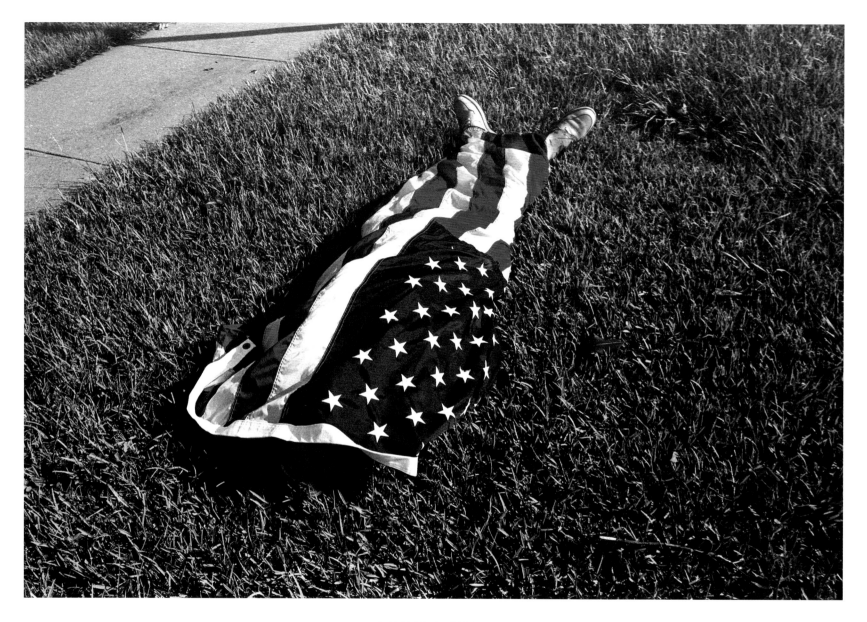

ANDY LEVIN

50

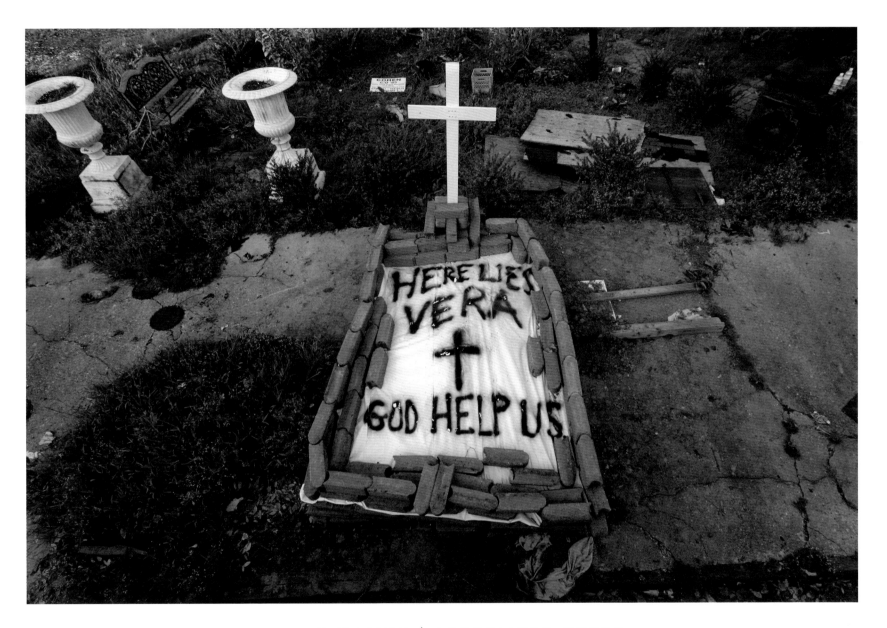

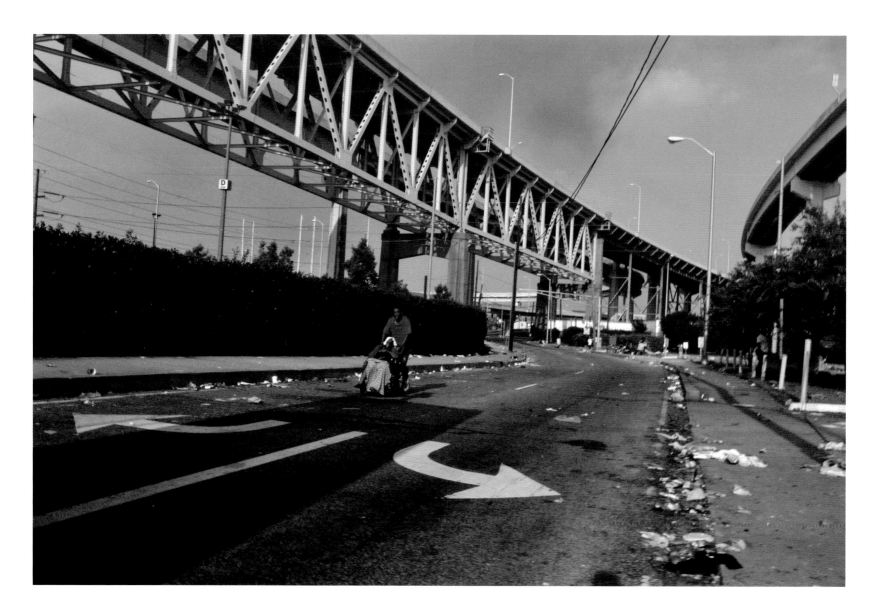

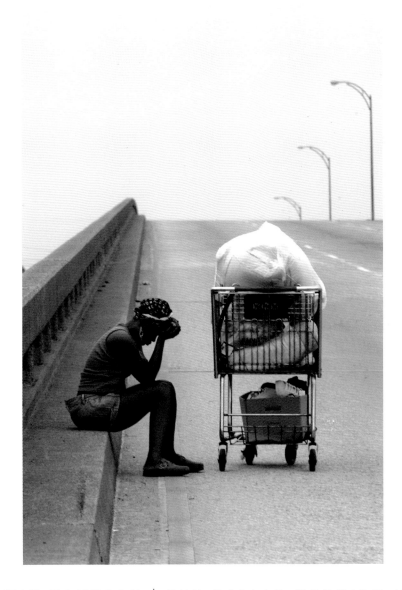

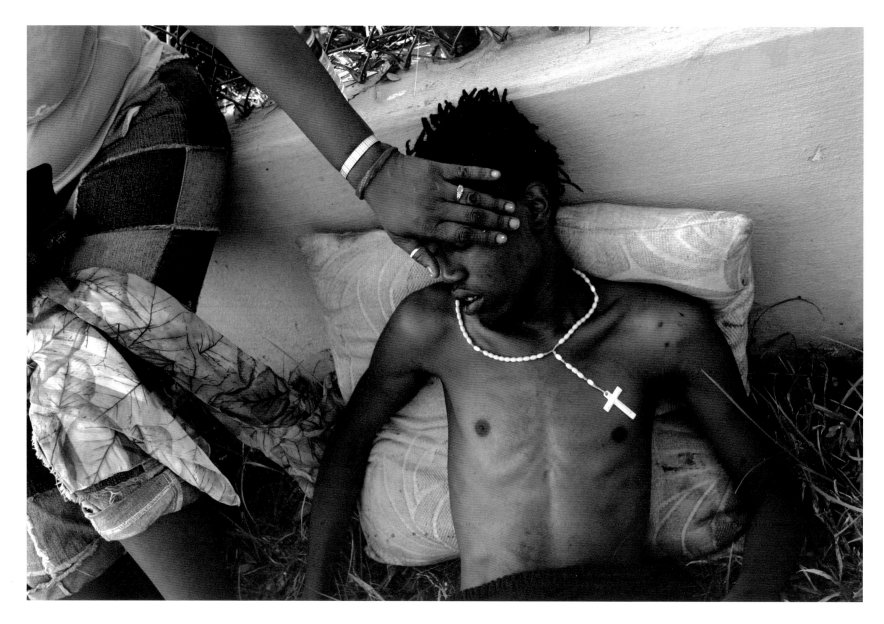

© TYLER HICKS | THE NEW YORK TIMES

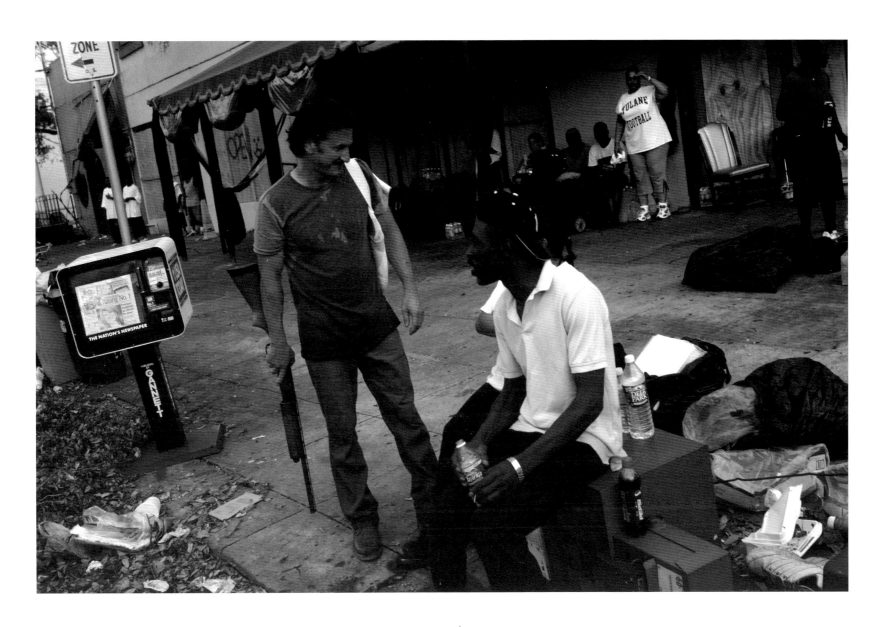

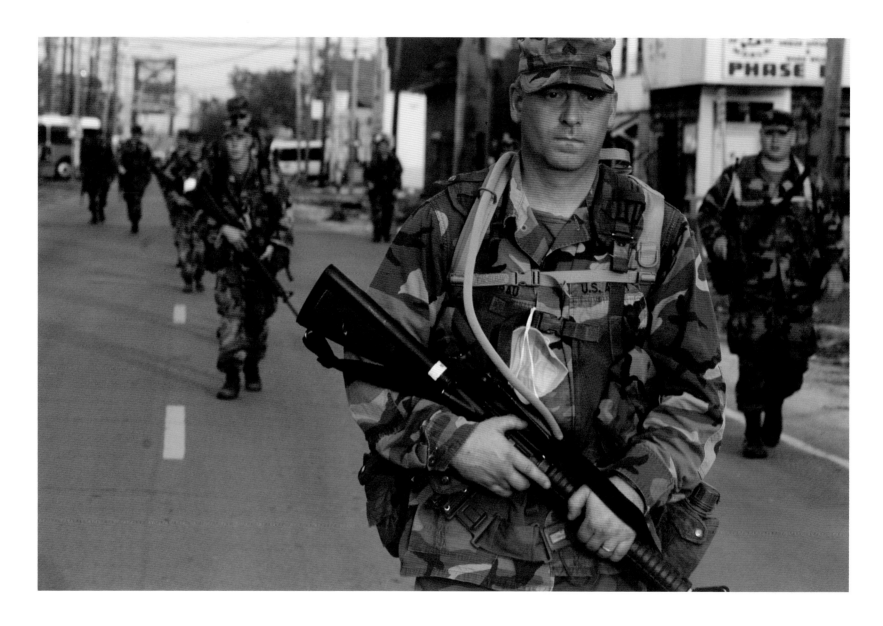

DAVID RAE MORRIS

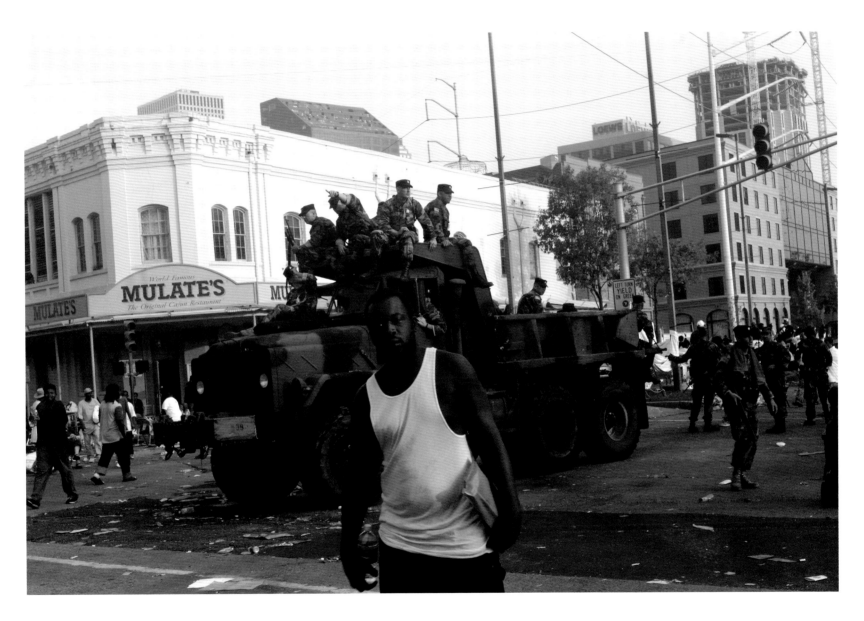

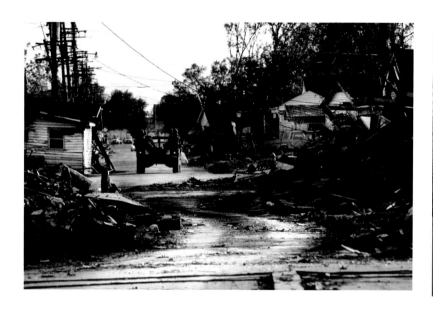

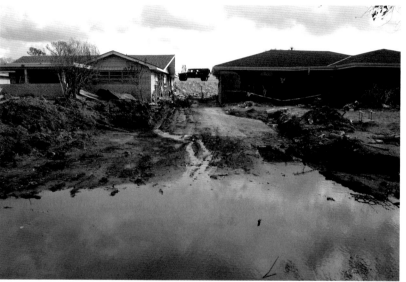

BRIAN GAUVIN

MARIANNA DAY MASSEY | ZUMA PRESS

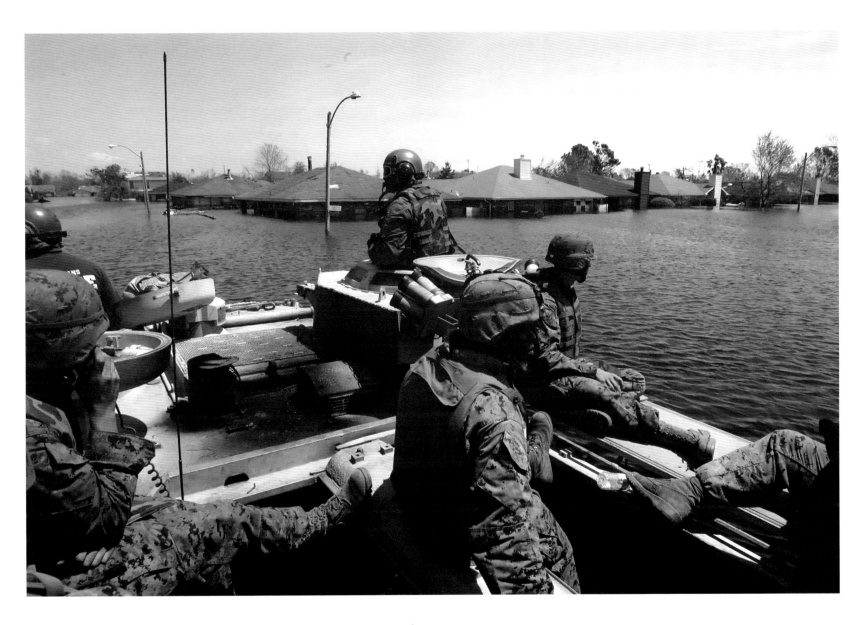

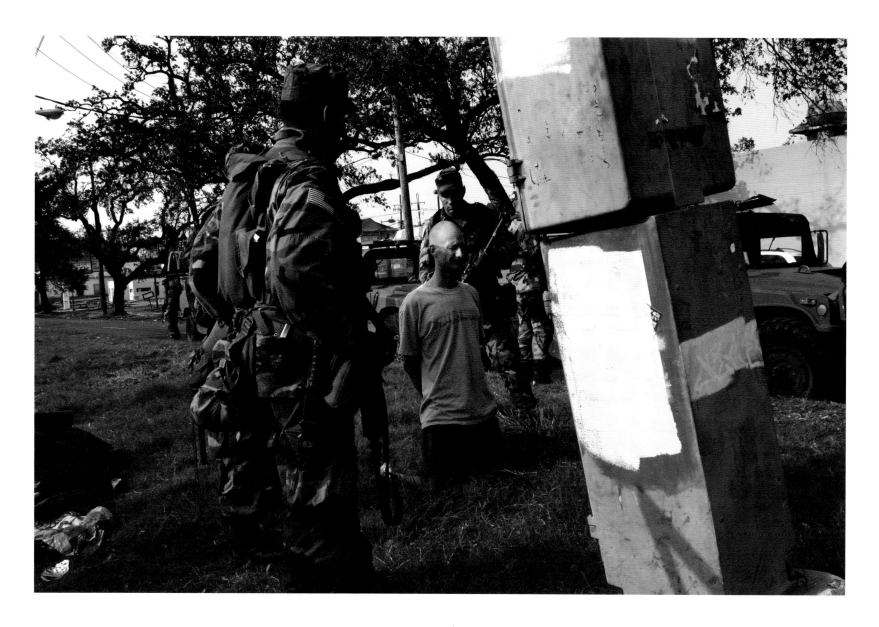

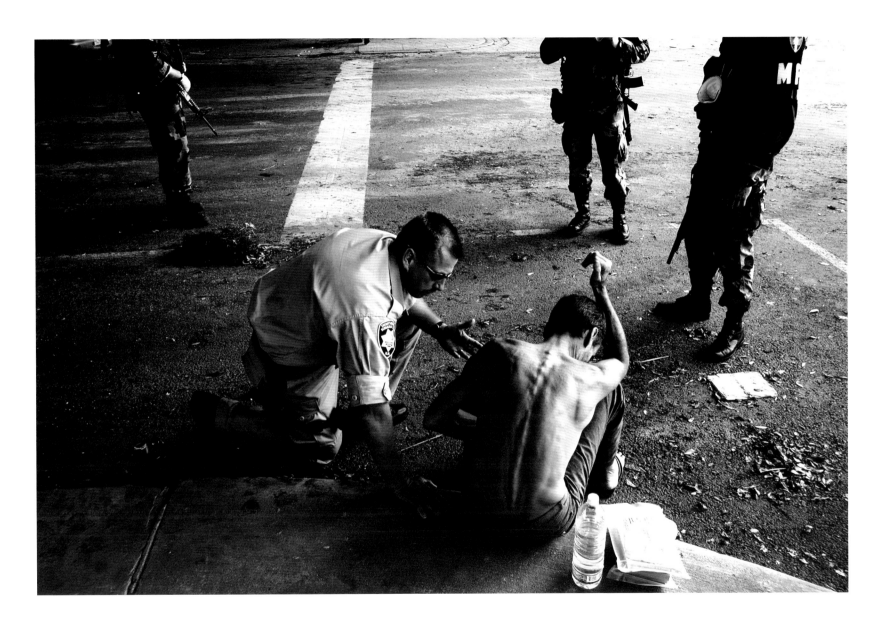

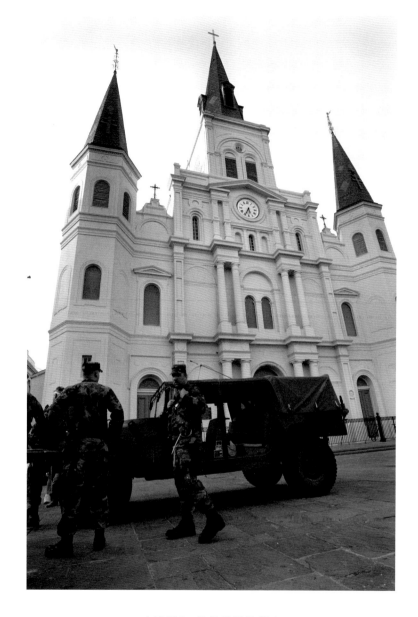

JUDI BOTTONI

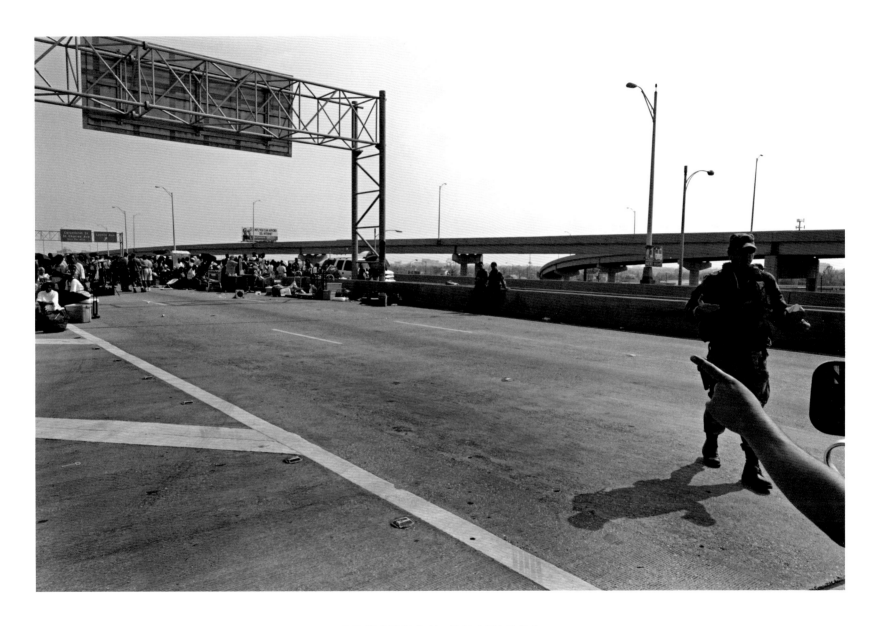

JONATHAN TRAVIESA

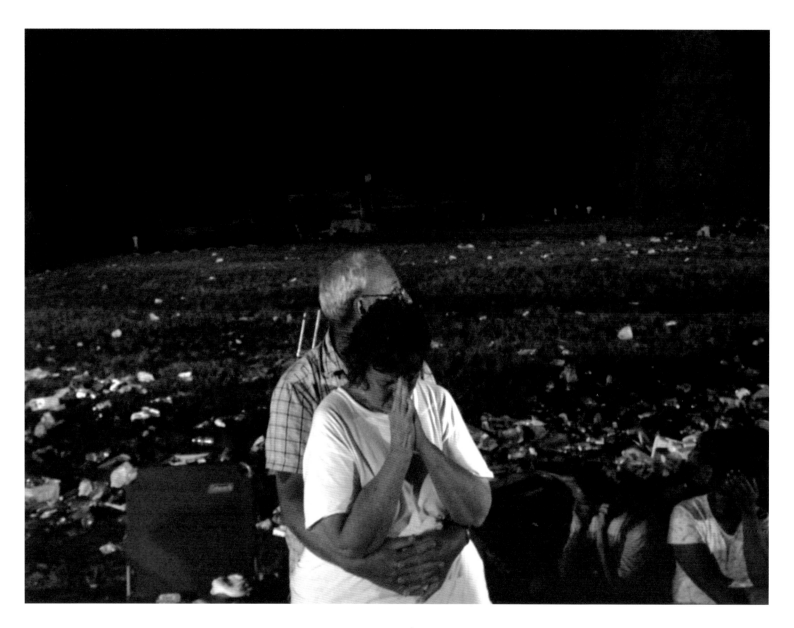

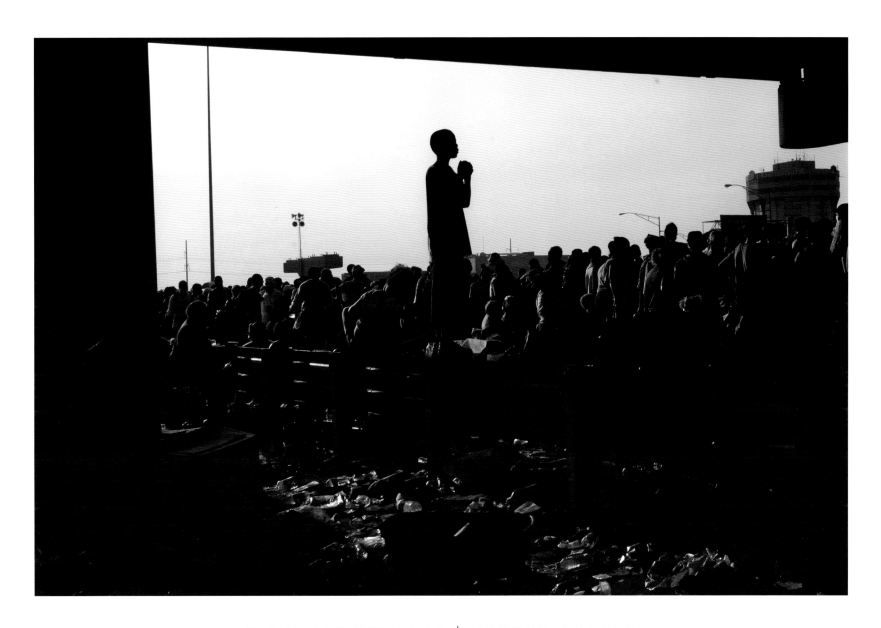

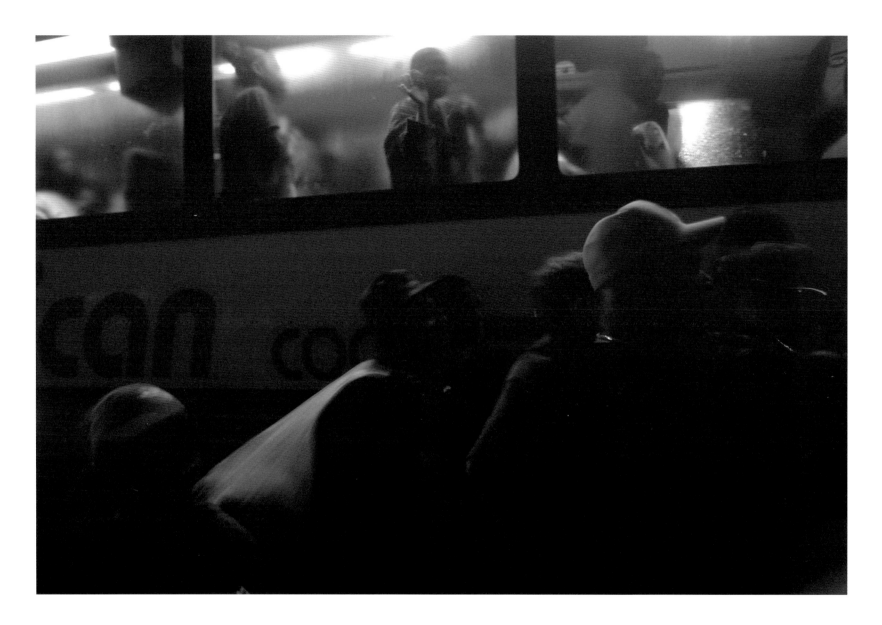

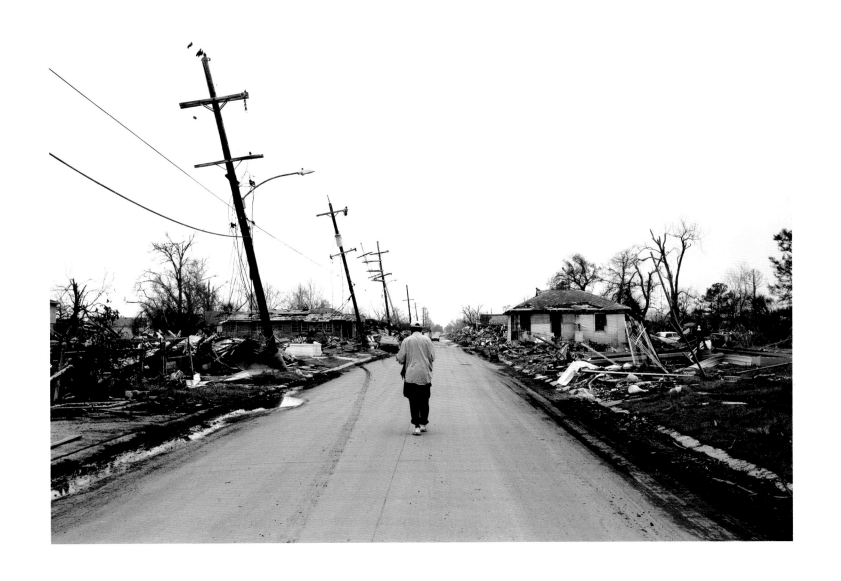

STEWART HARVEY

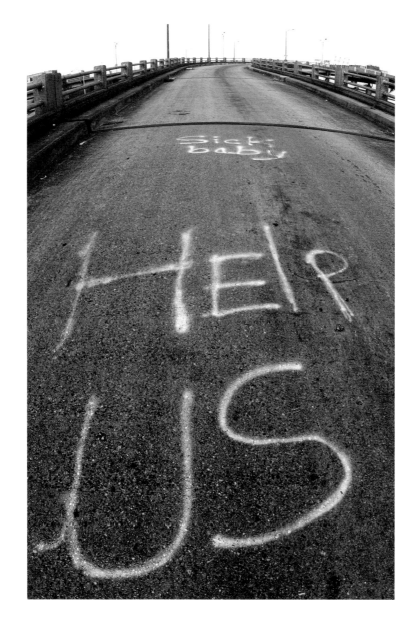

V.L. SANDERS, JR.

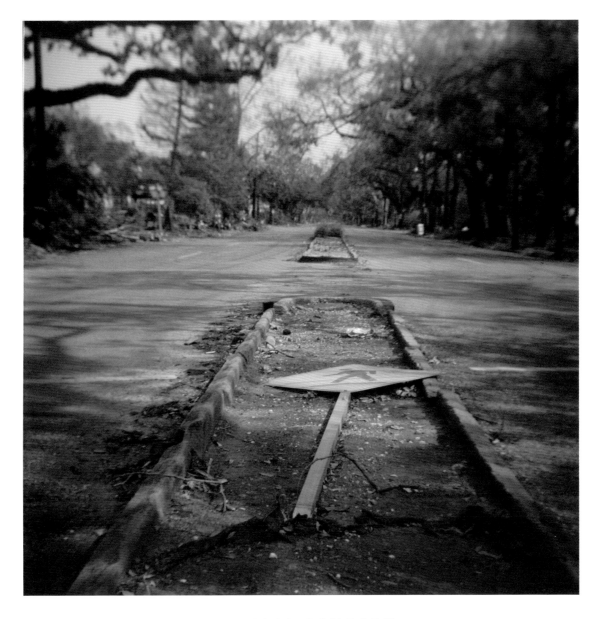

VANESSA SANBORN

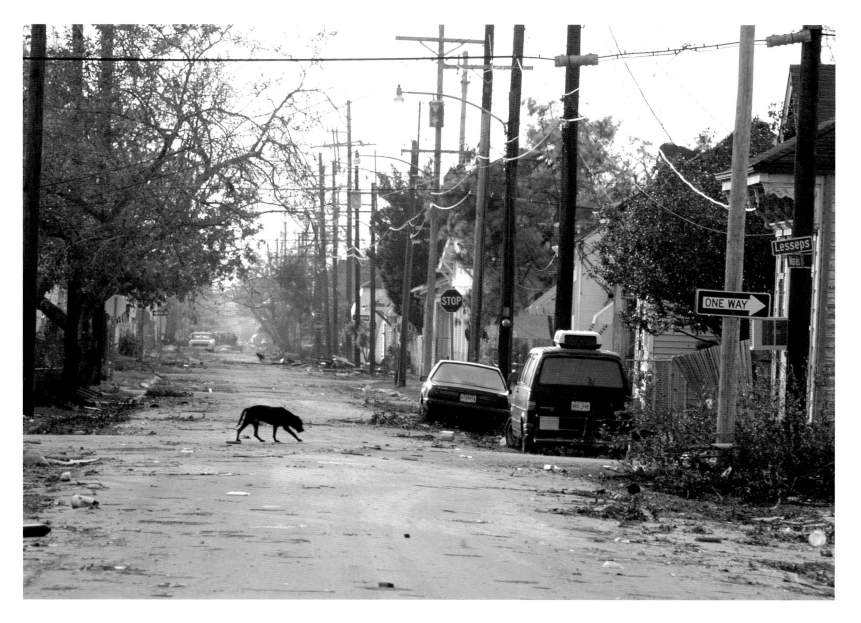

DAVID RAE MORRIS

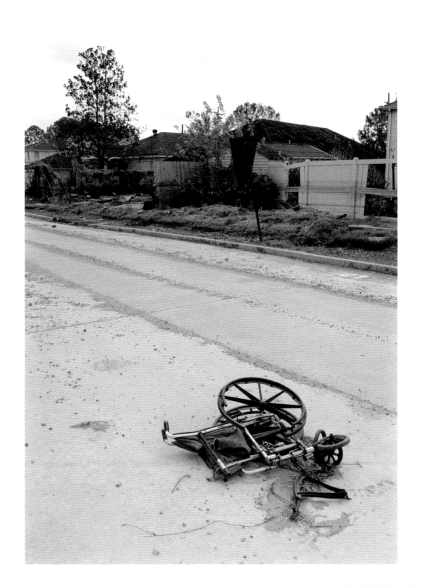

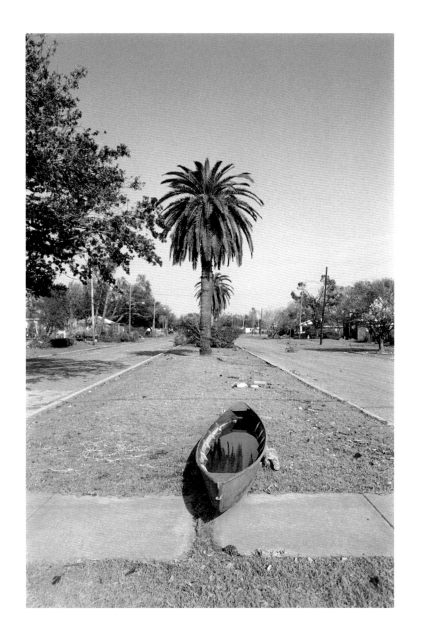

JEFFREY J. THOMAS

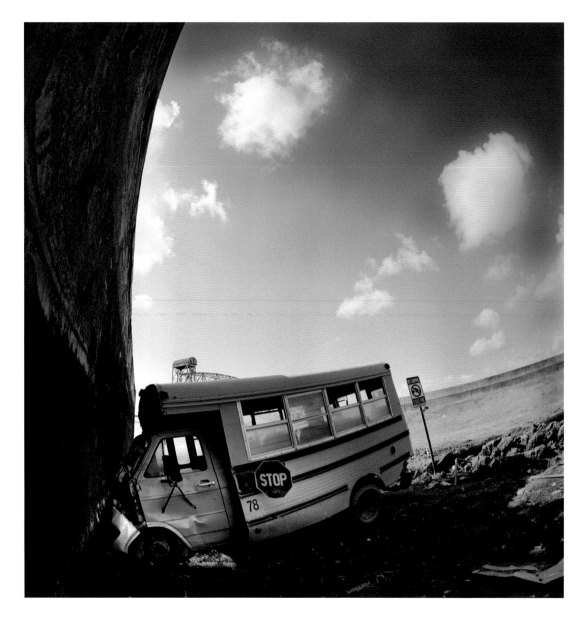

SHANNON K. BRINKMAN

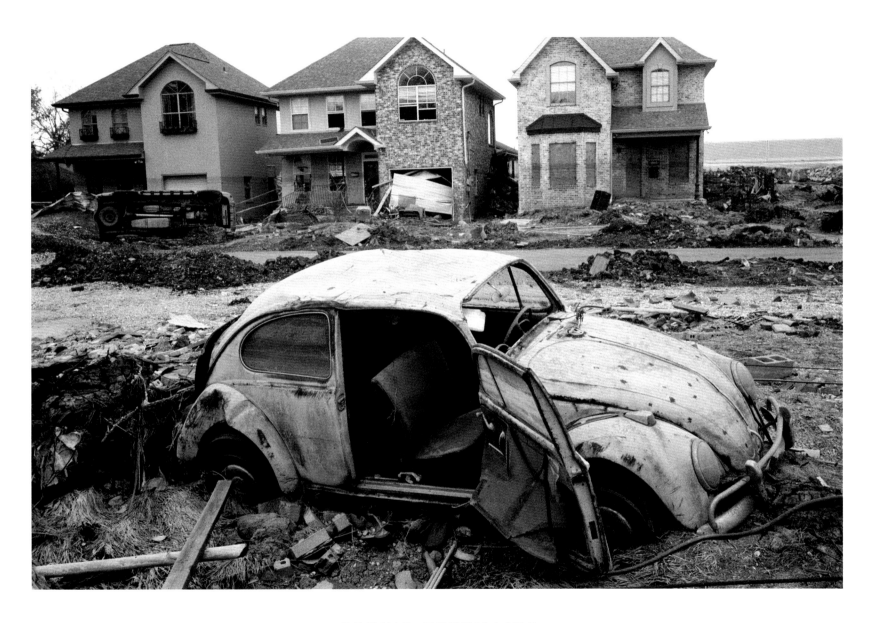

DENNIS COUVILLION

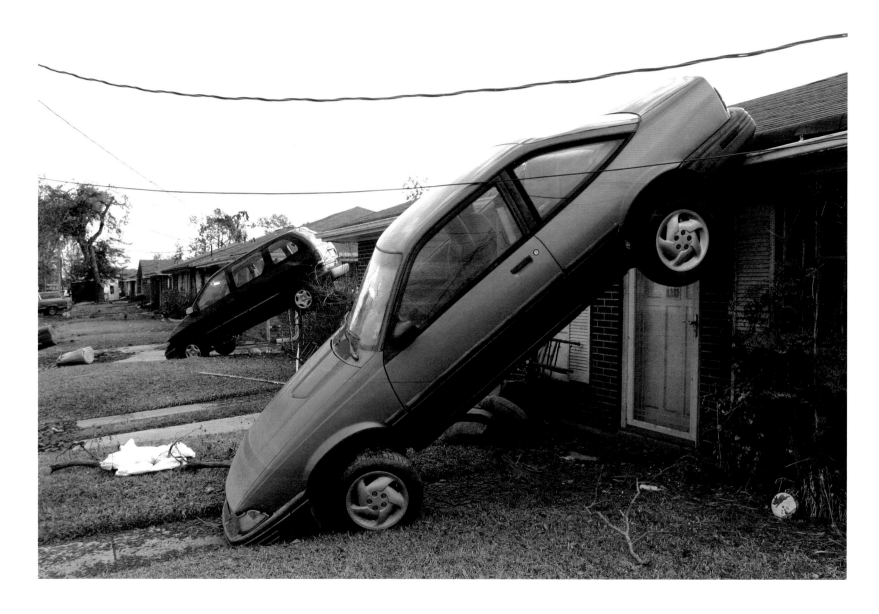

ANDY LEVIN

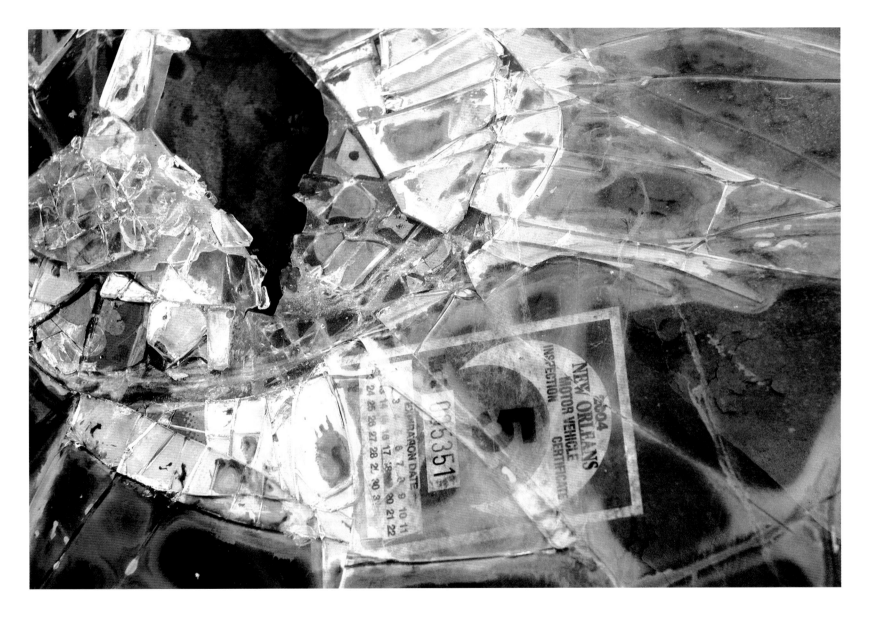

LESLIE PARR

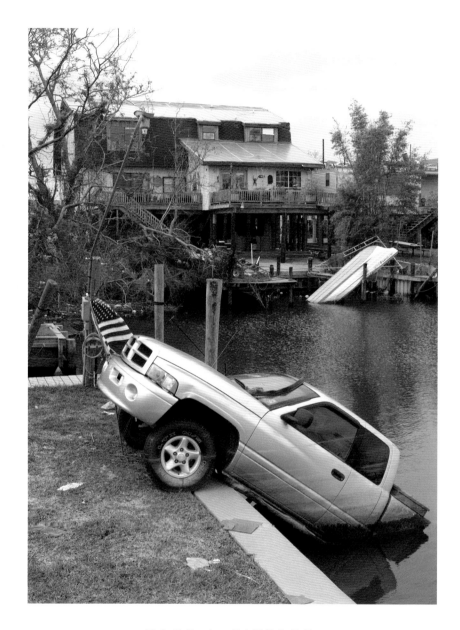

MARK J. SINDLER

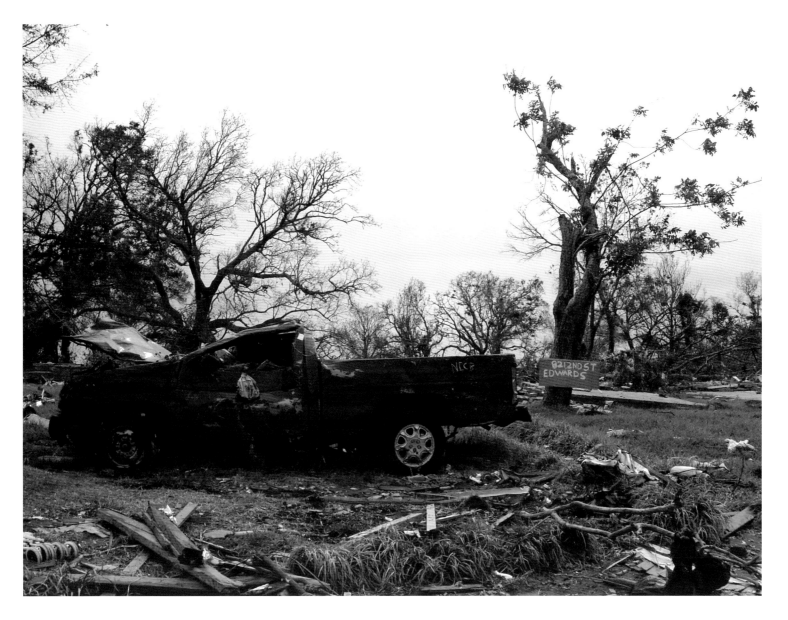

IAN J. COHN

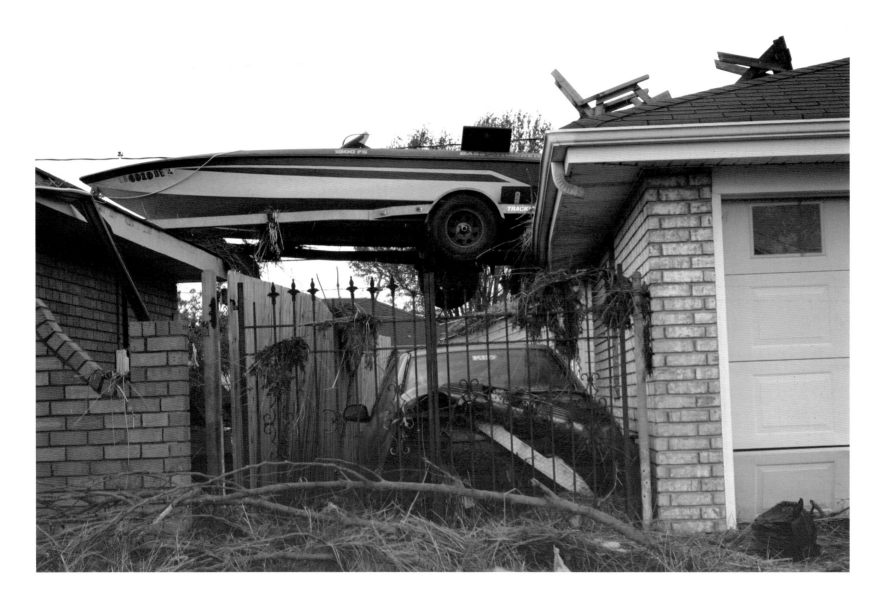

CONNIE ALLOTTO

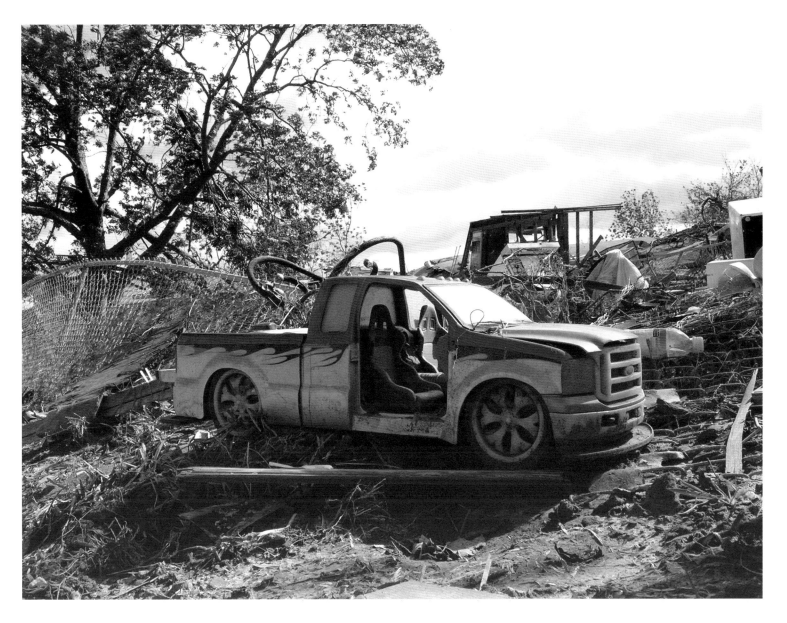

MALCOLM McCLAY

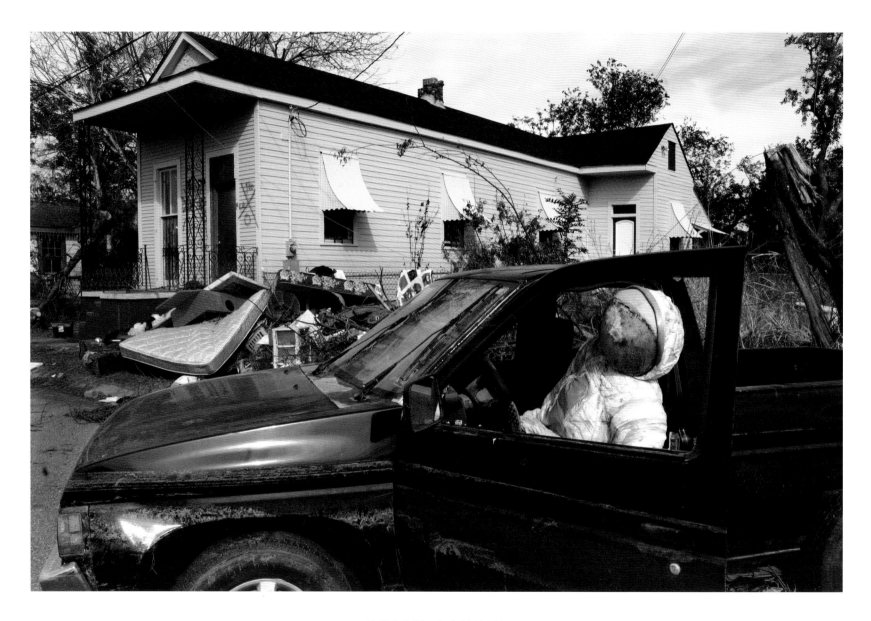

BRIAN GAUVIN

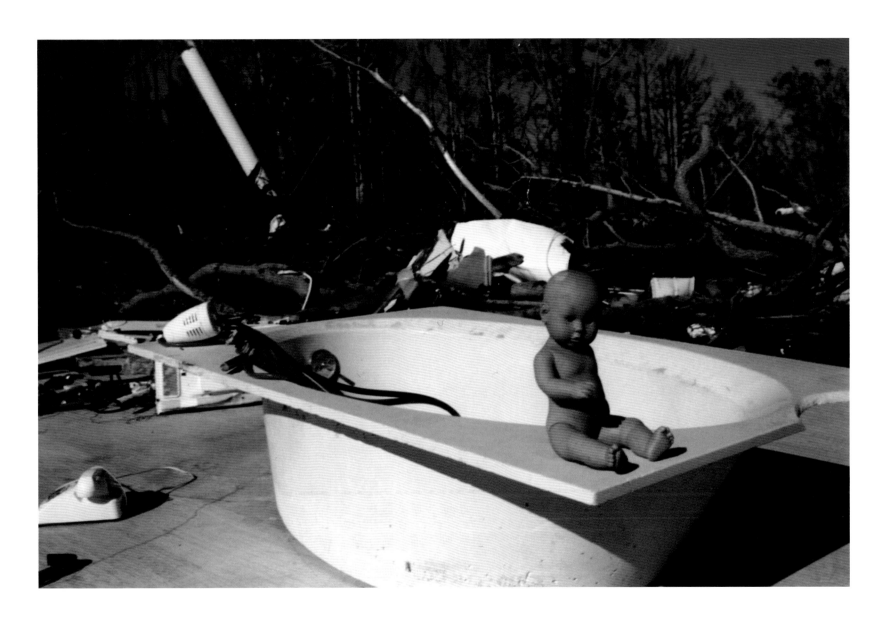

RITA POSSELT

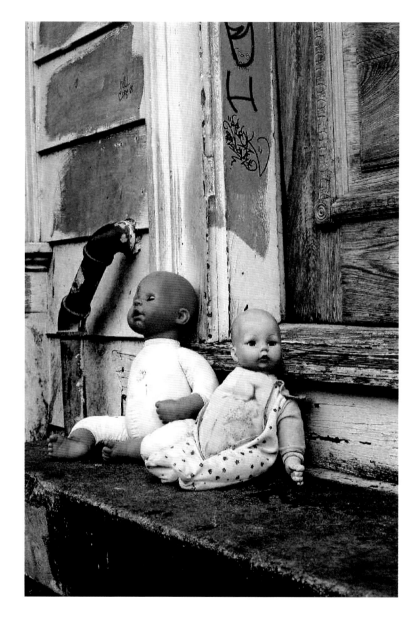

MELINDA SHELTON

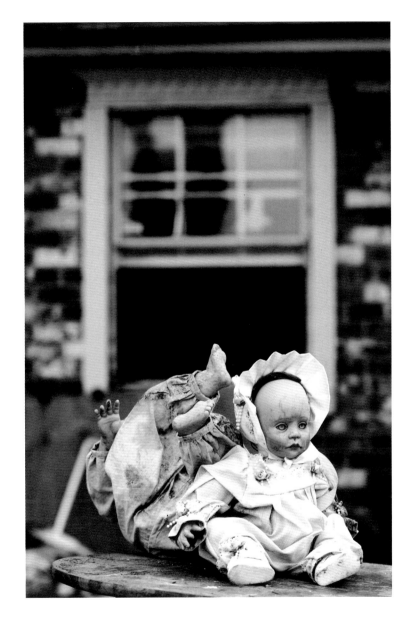

BRIAN GAUVIN

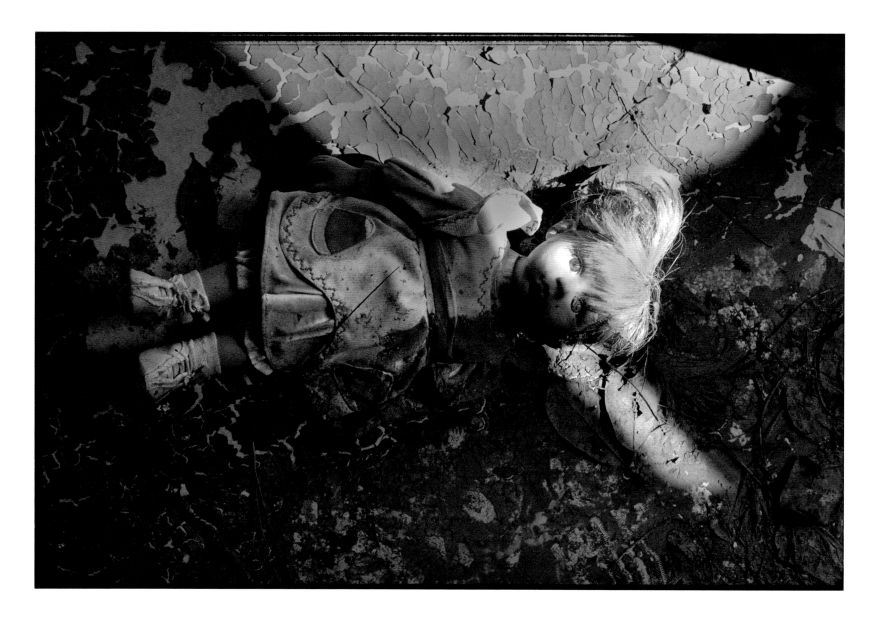

KATHY ANDERSON

84

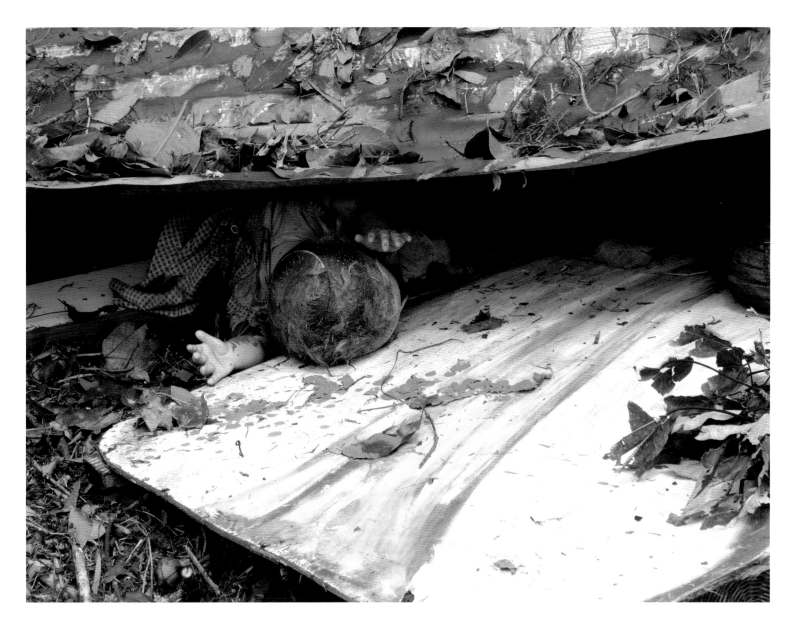

JAMES W. de BUYS

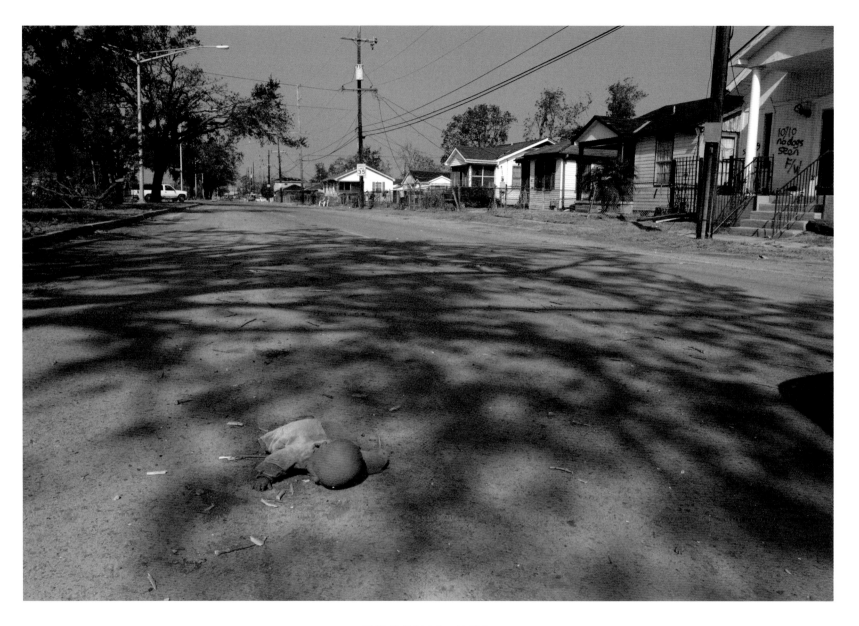

EUGENIA UHL

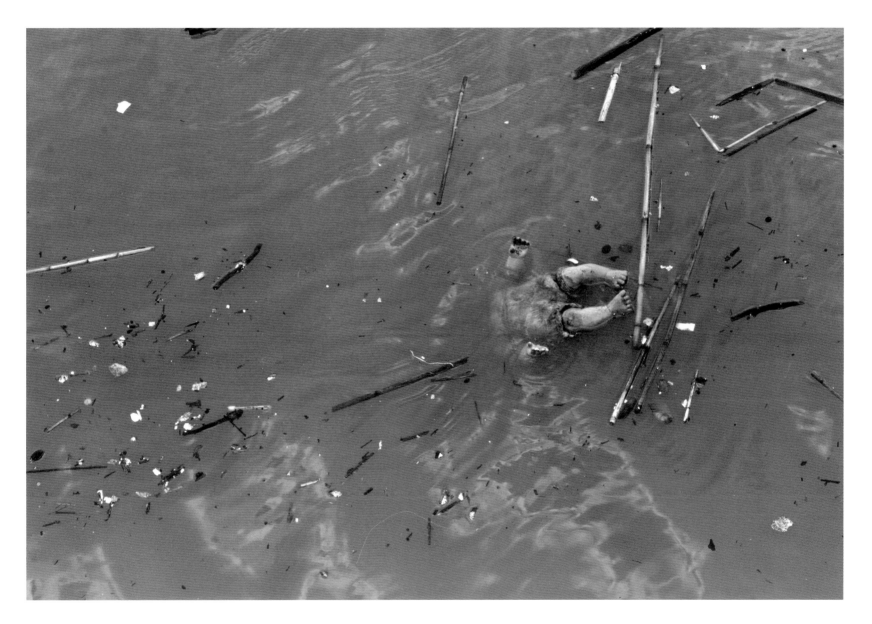

ANDY LEVIN

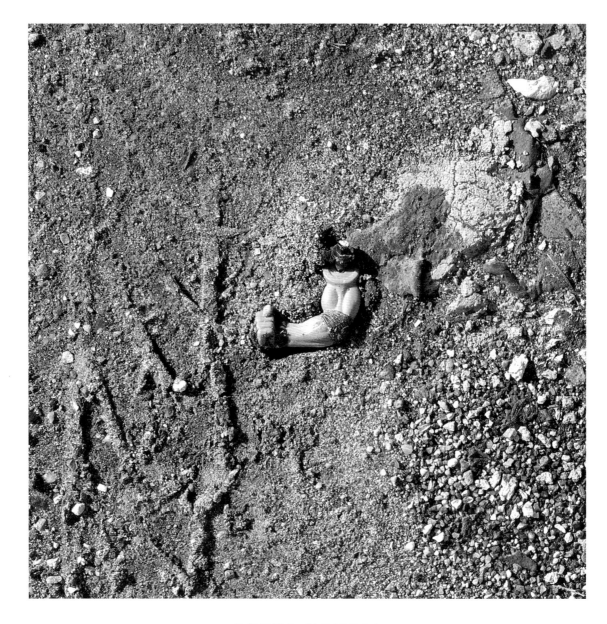

DEBRA HOWELL

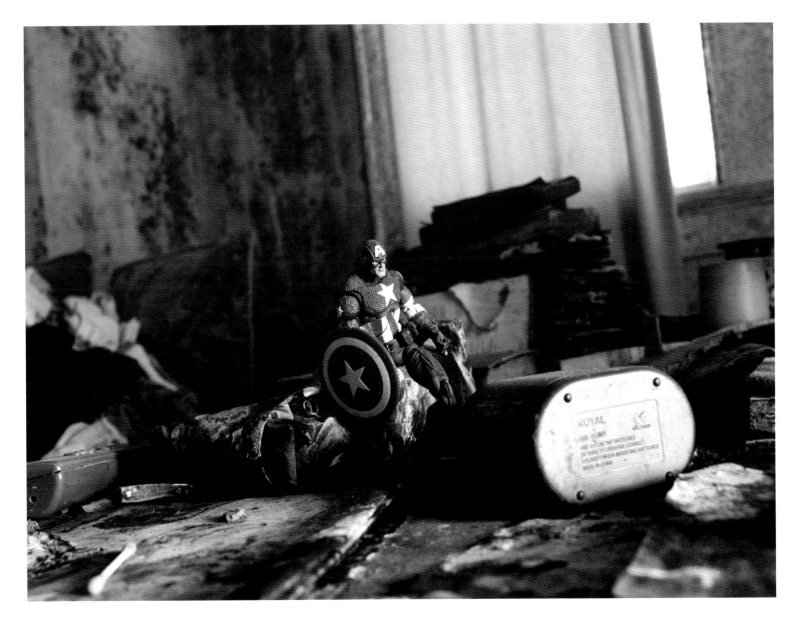

DONNA HURT

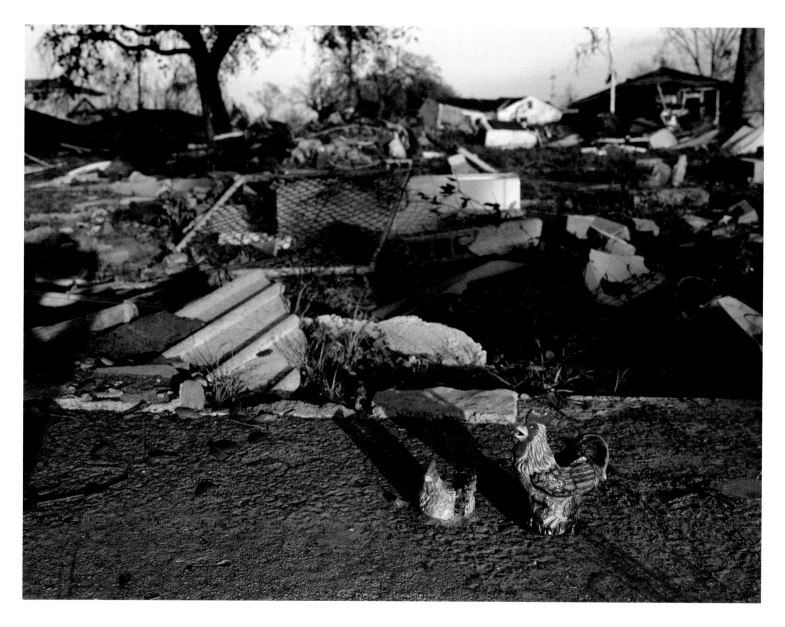

DONNA HURT

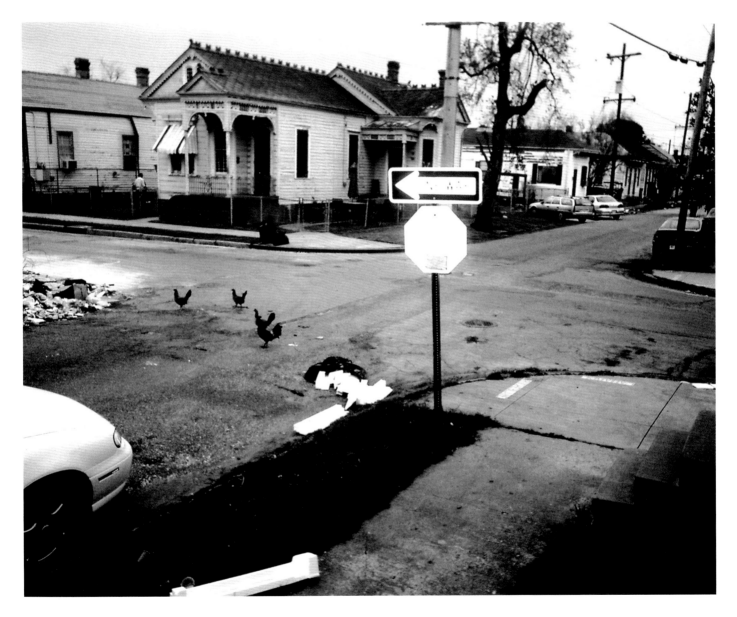

AUDREY ANNA FRANKLIN | THE NEW ORLEANS KID CAMERA PROJECT

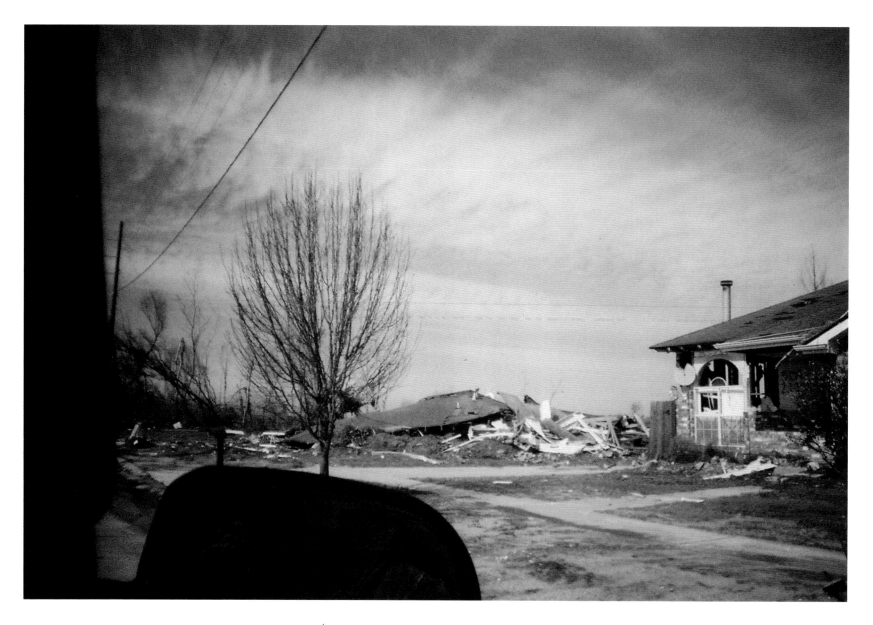

KATELYN ATKINSON | THE NEW ORLEANS KID CAMERA PROJECT

92

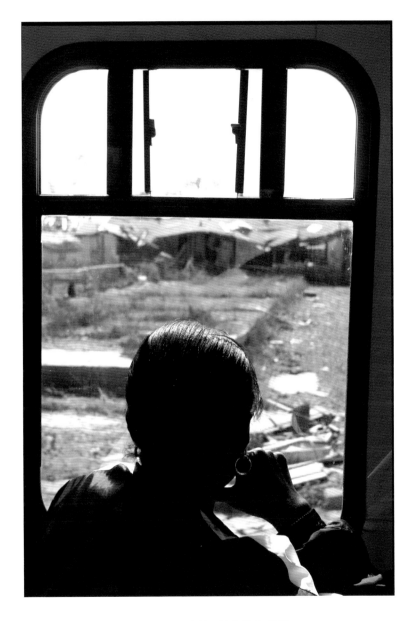

CHARLIE VARLEY

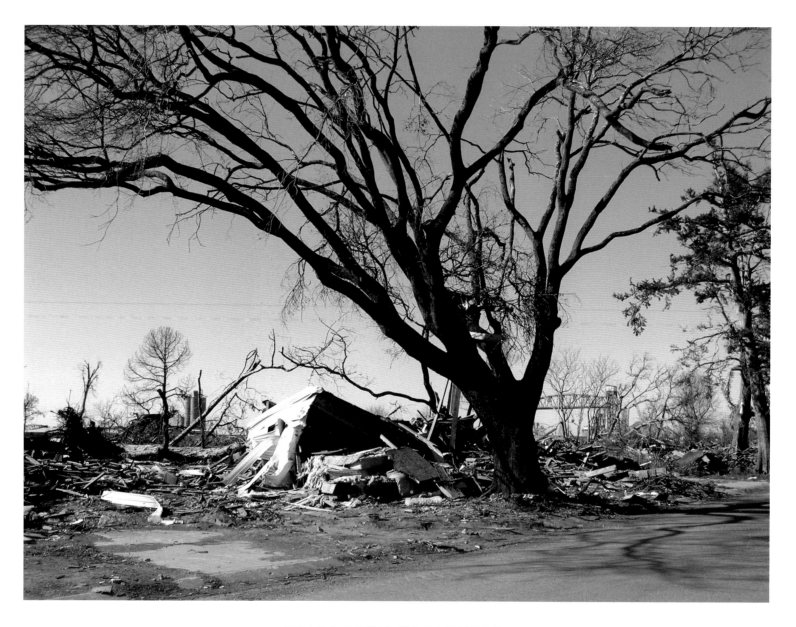

ELIZABETH KLEINVELD

BRIAN GAUVIN

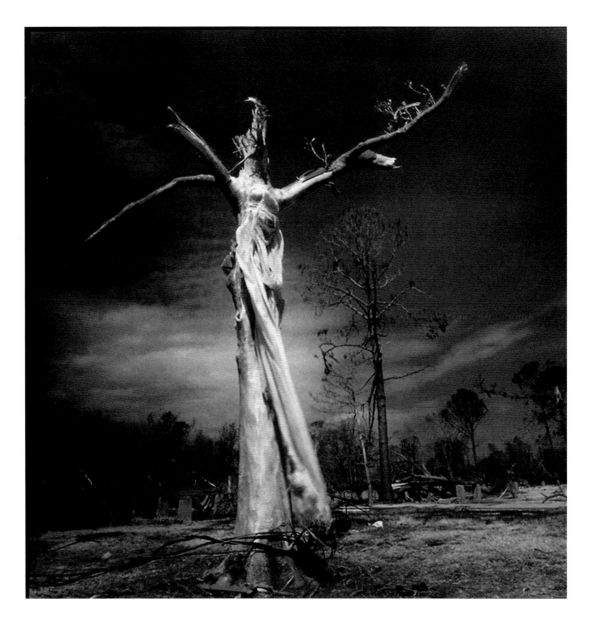

VICTORIA RYAN

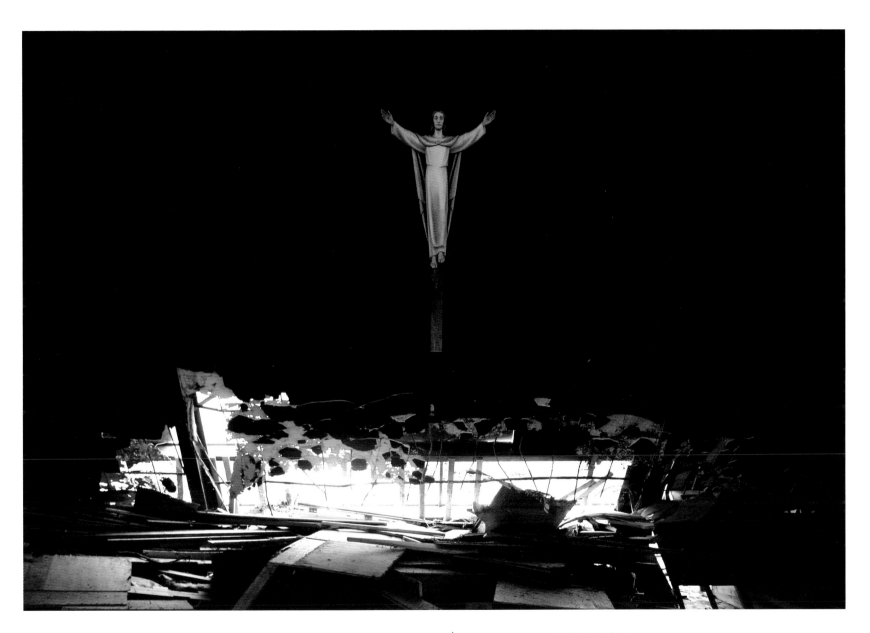

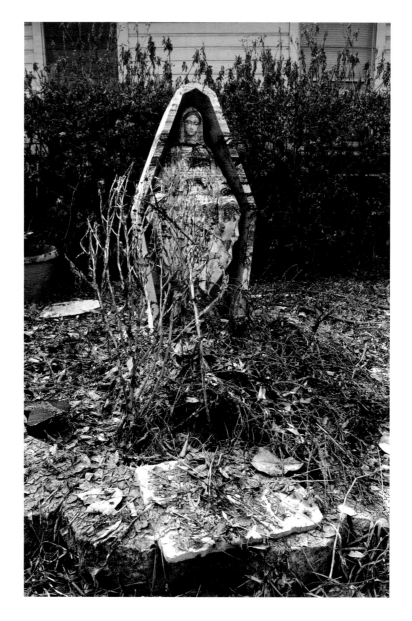

MIKE SMITH

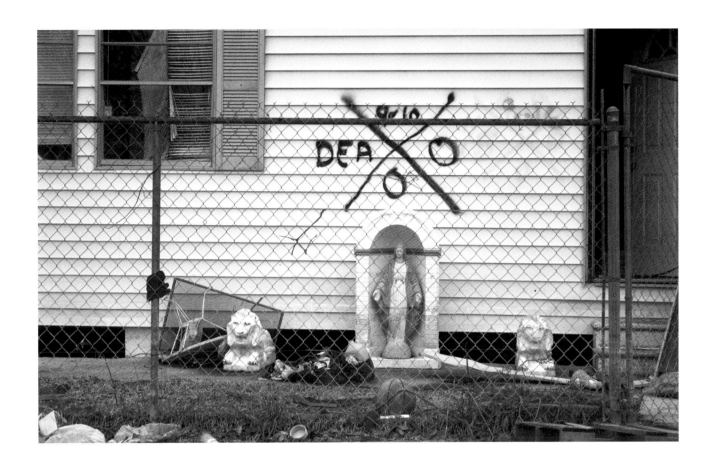

TINA FREEMAN

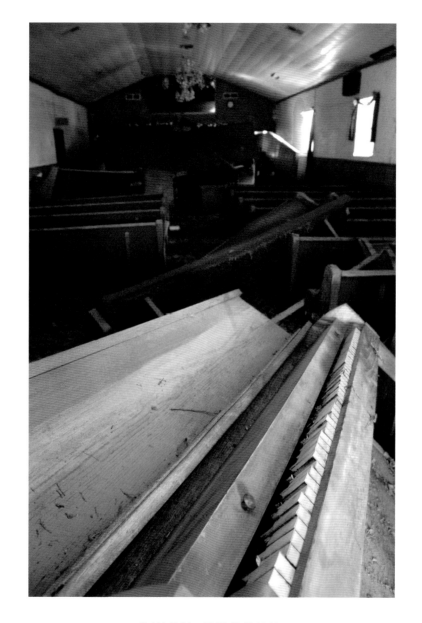

OWEN MURPHY

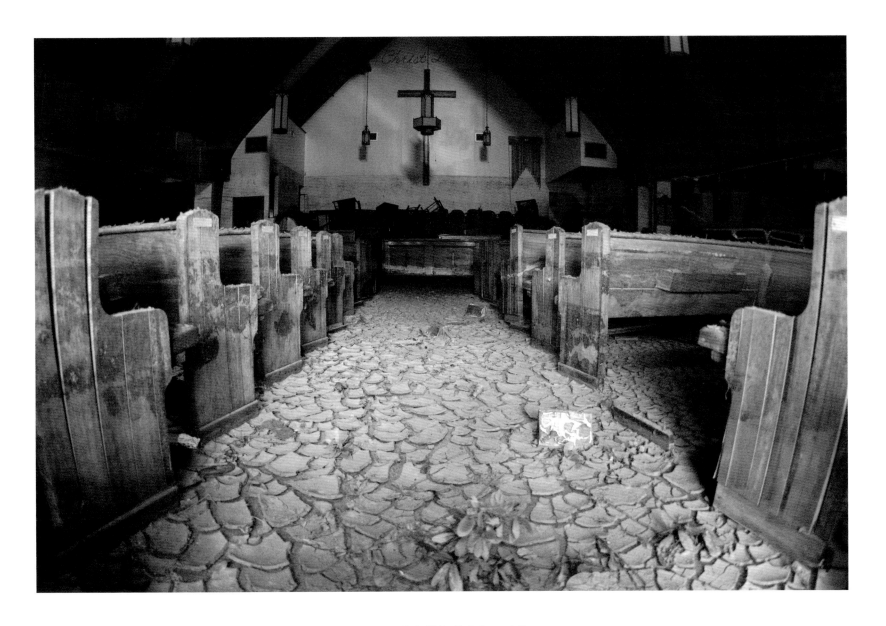

V.L. SANDERS, JR.

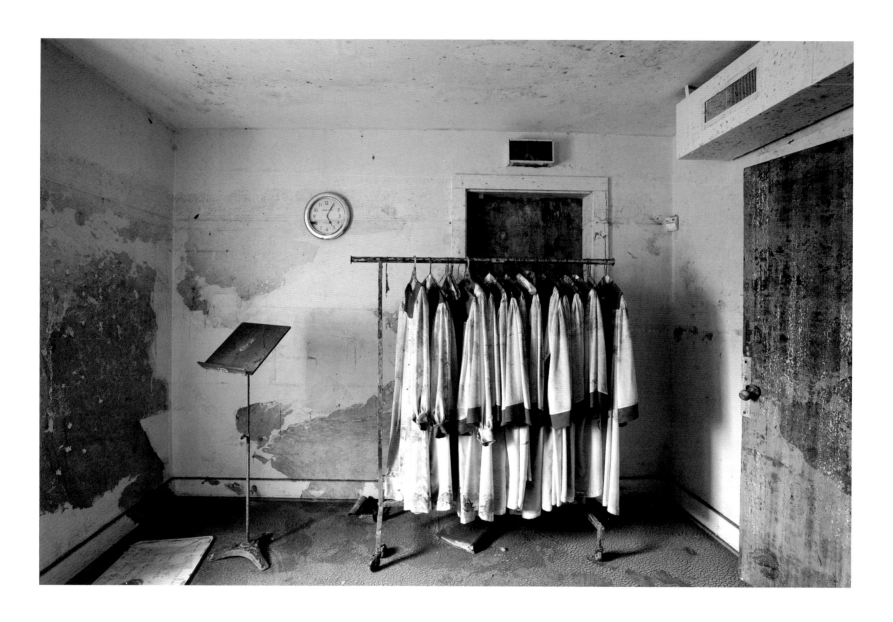

JIM LOMMASSON

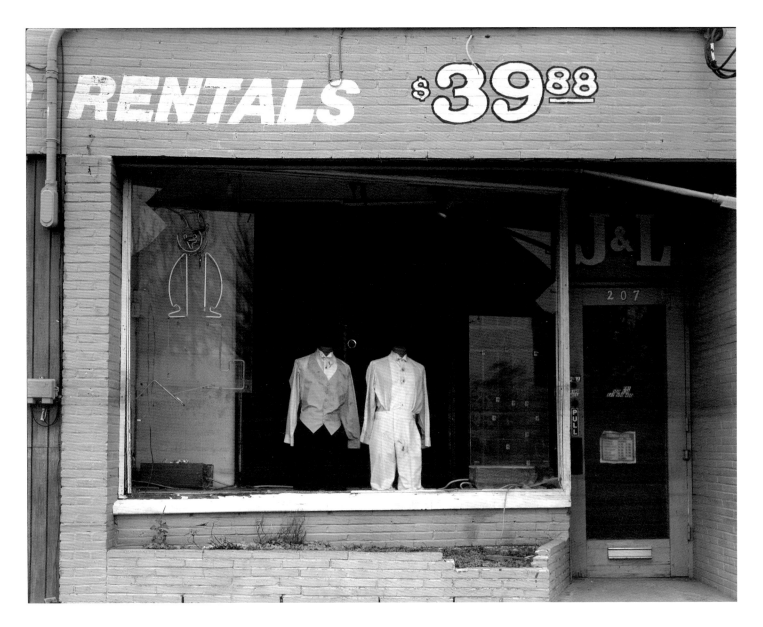

SETHASAK BOONCHAI

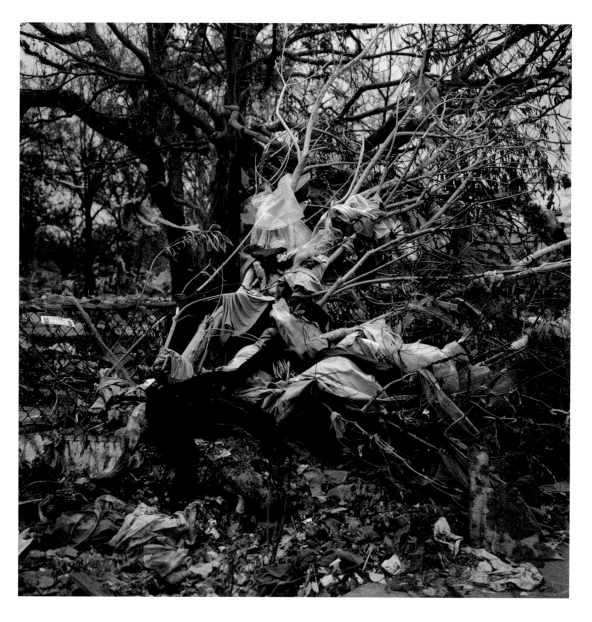

LYNN DAVIS

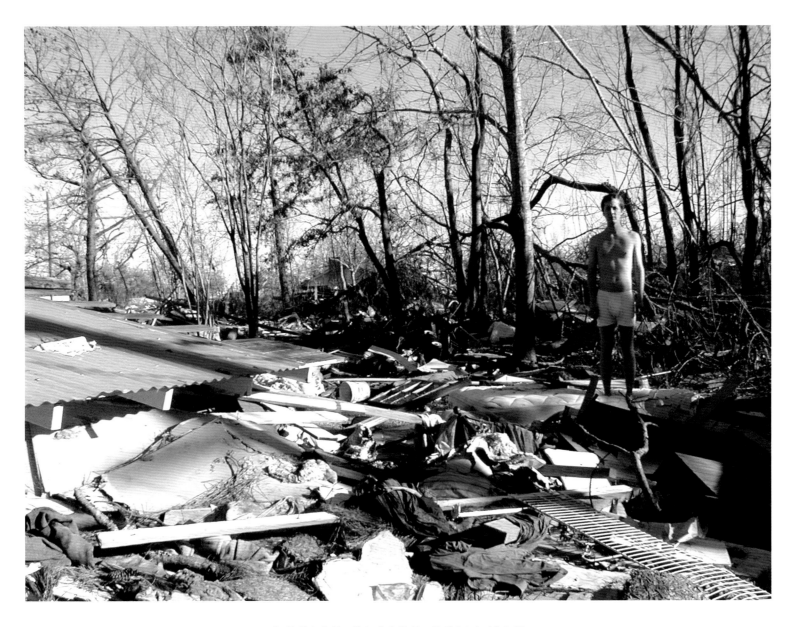

LESLIE-CLAIRE SPILLMAN

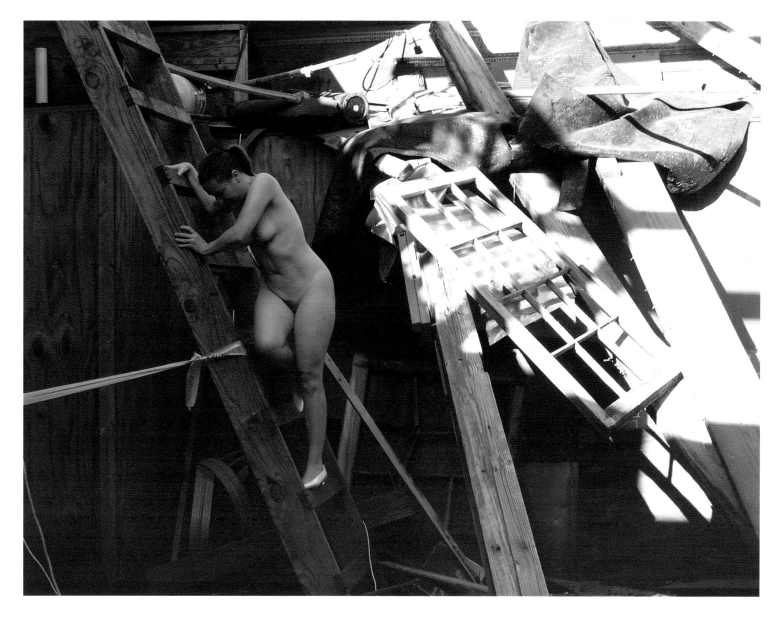

HEATHER WEATHERS

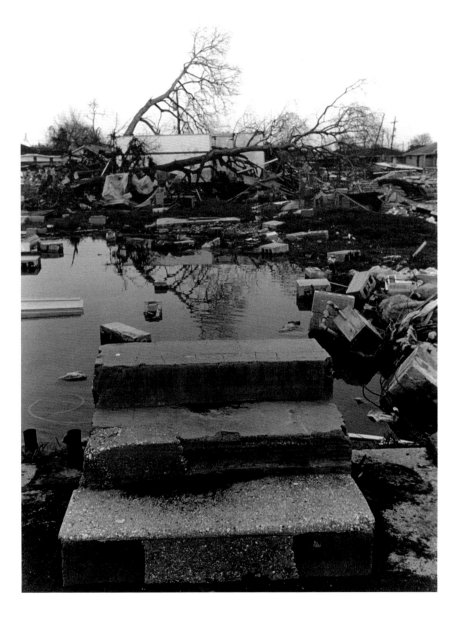

REGGIE SCANLAN

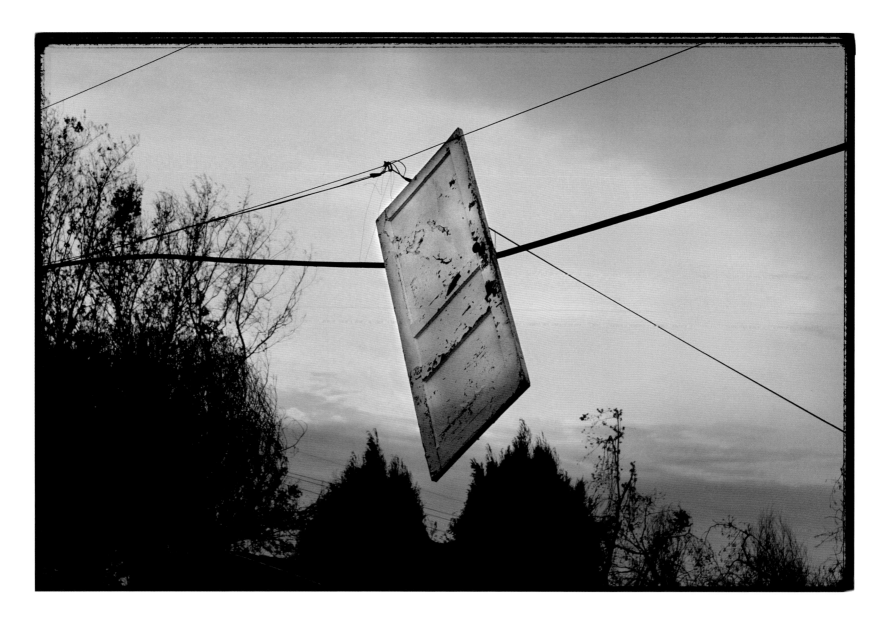

KATHY ANDERSON

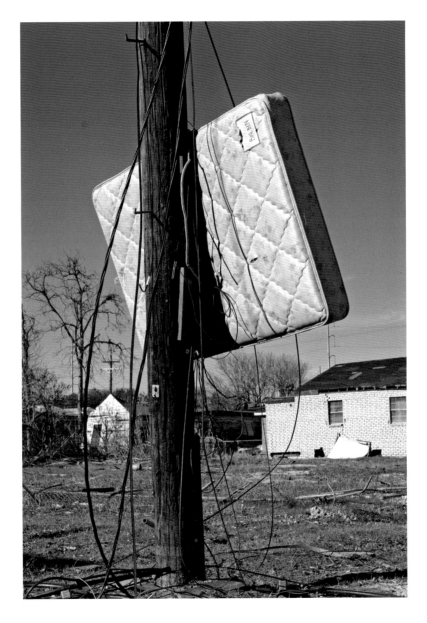

MARK J. SINDLER

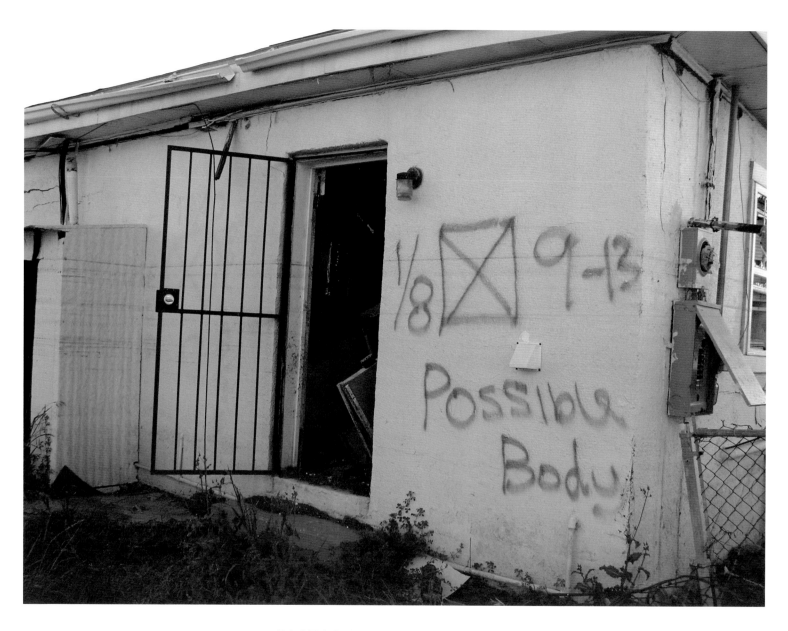

ELIZABETH KLEINVELD

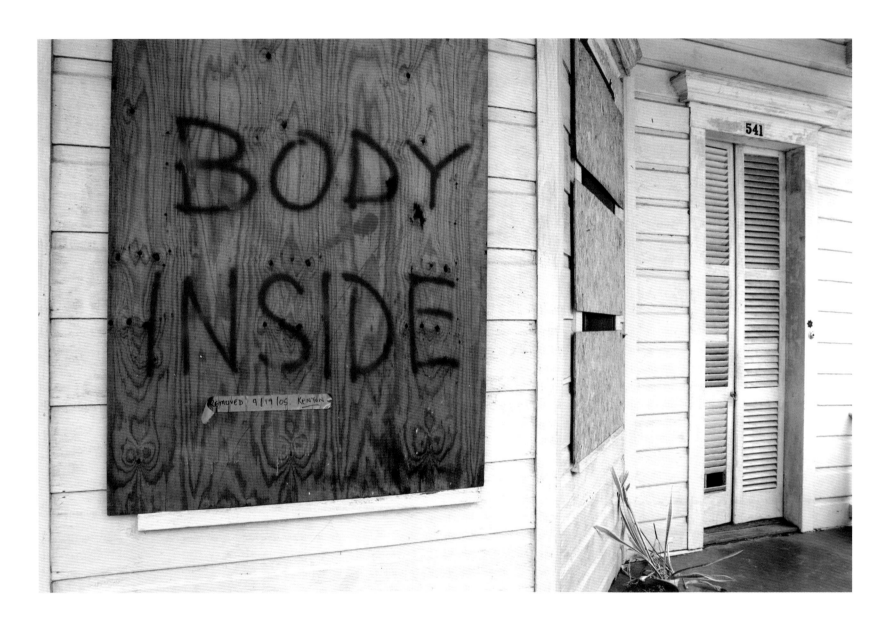

CHARLIE VARLEY

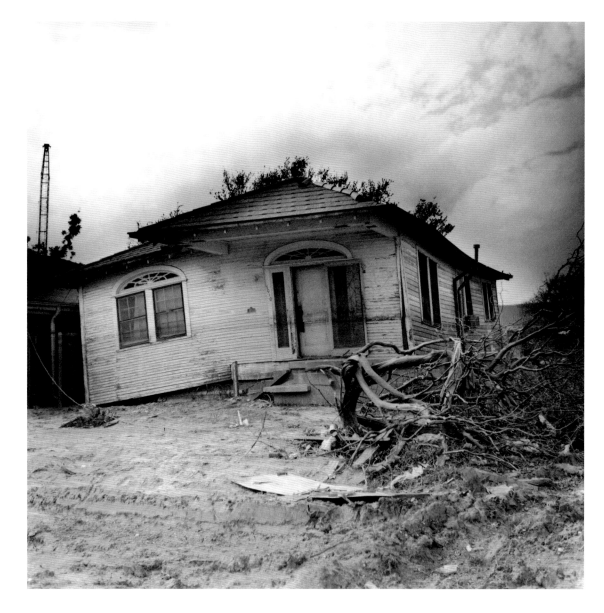

RENEE E. ALLIE

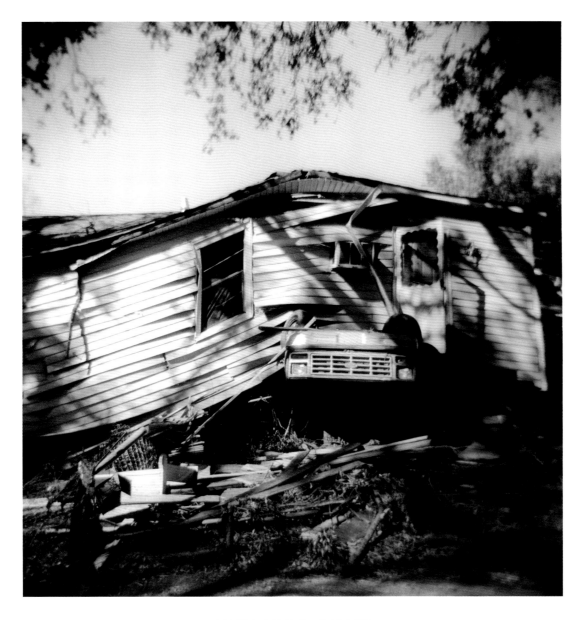

JENNIFER SHAW

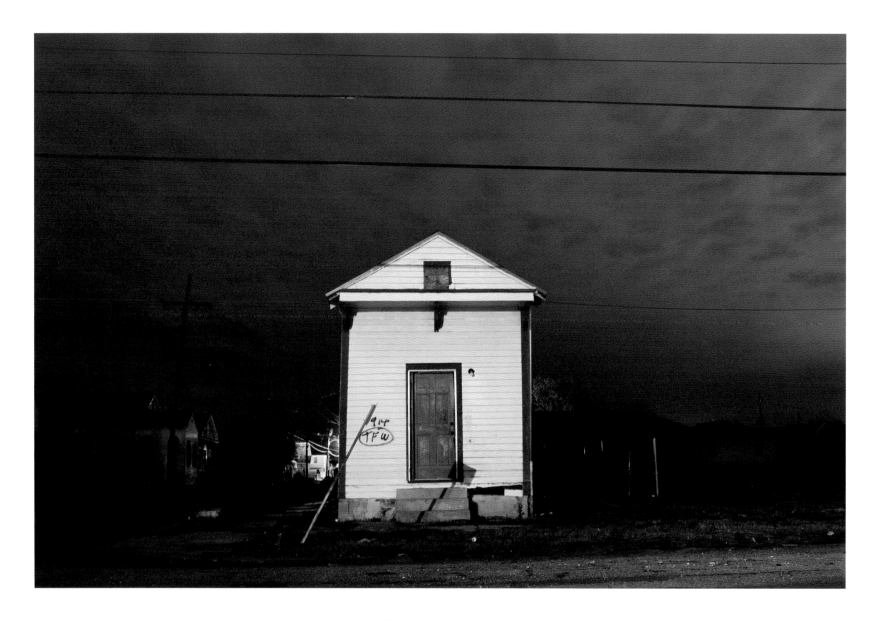

FRANK RELLE

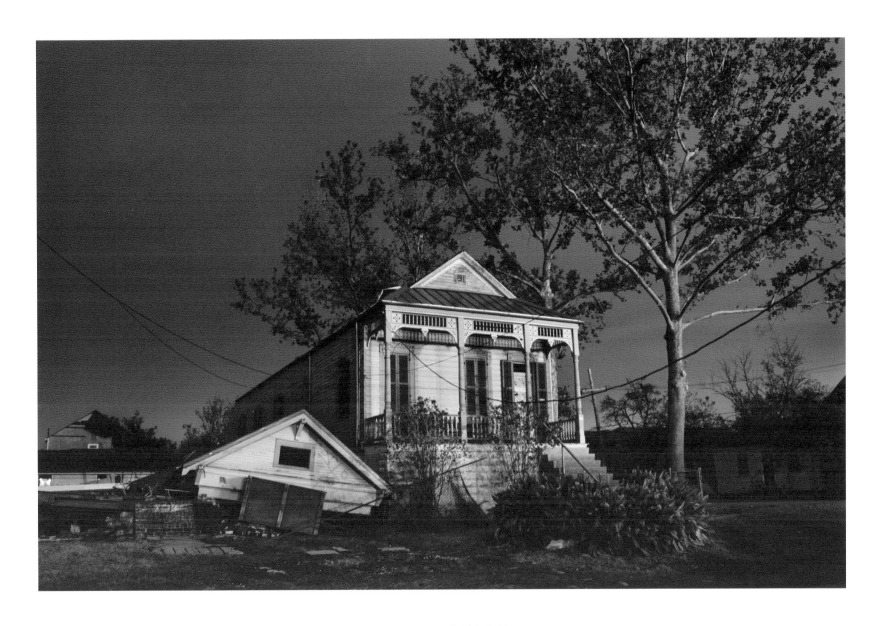

FRANK RELLE

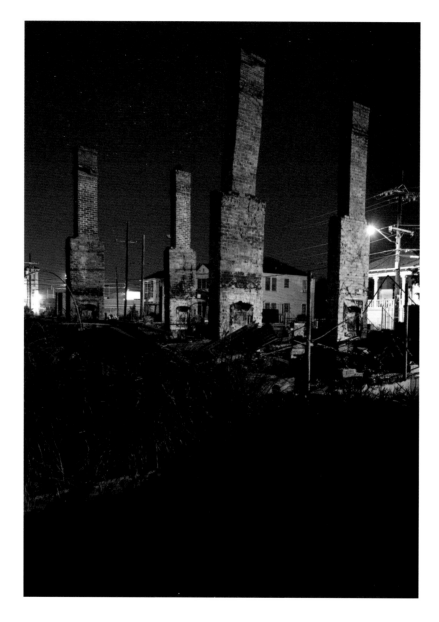

JACKSON HILL

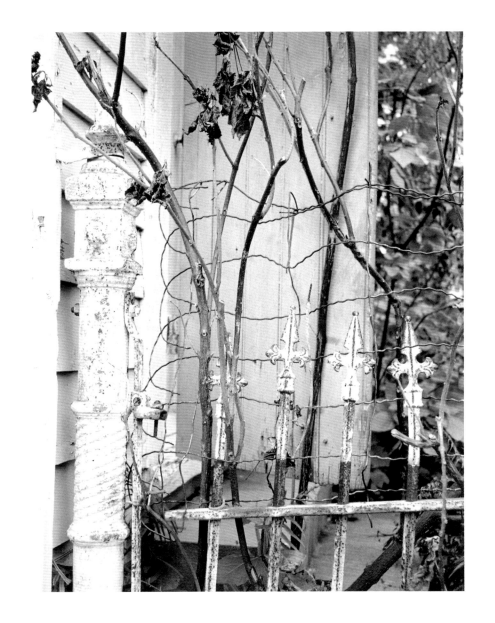

MELINDA SHELTON

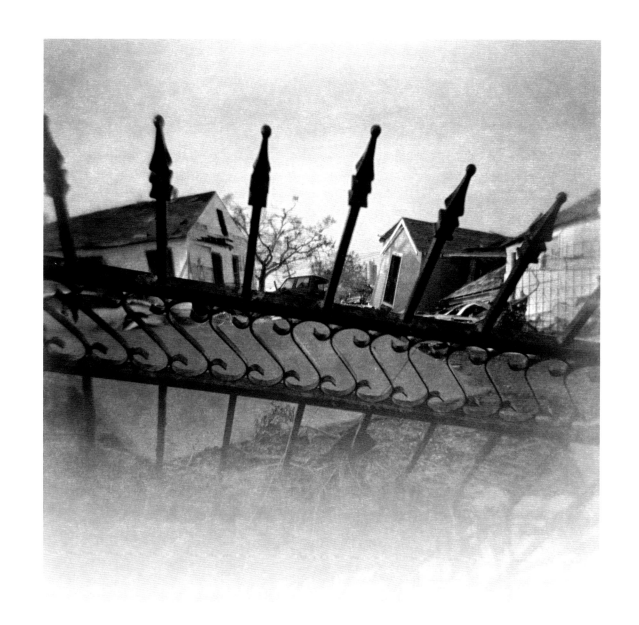

LOUVIERE + VANESSA

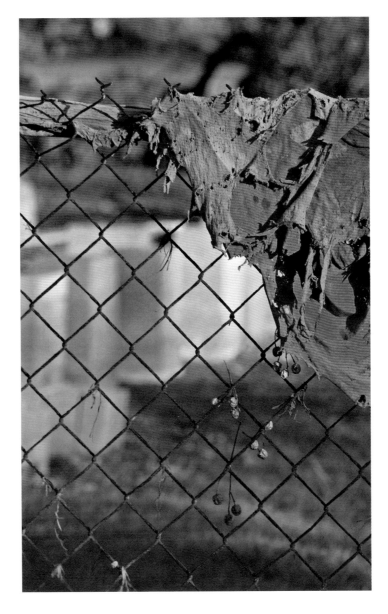

SANDRA BURSHELL

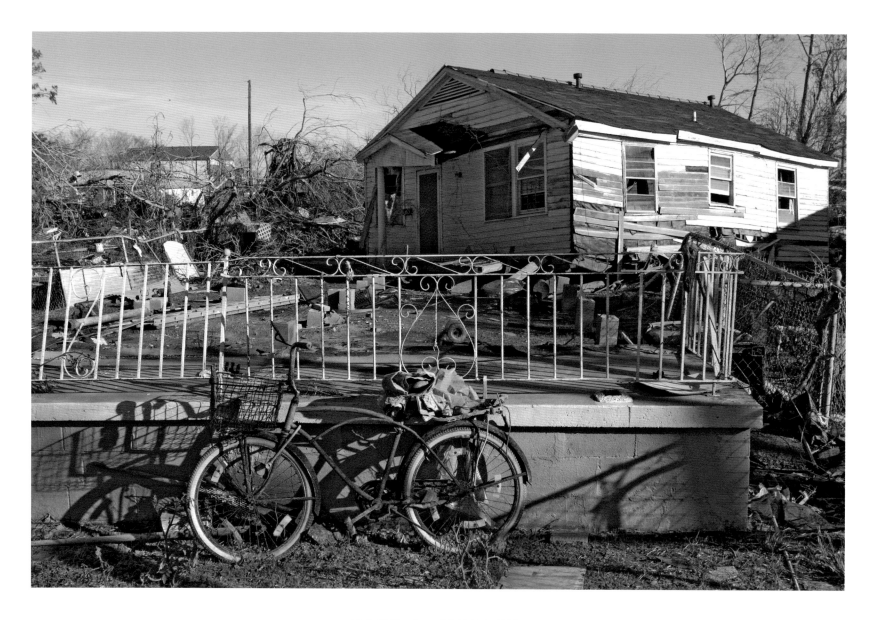

MARK J. SINDLER

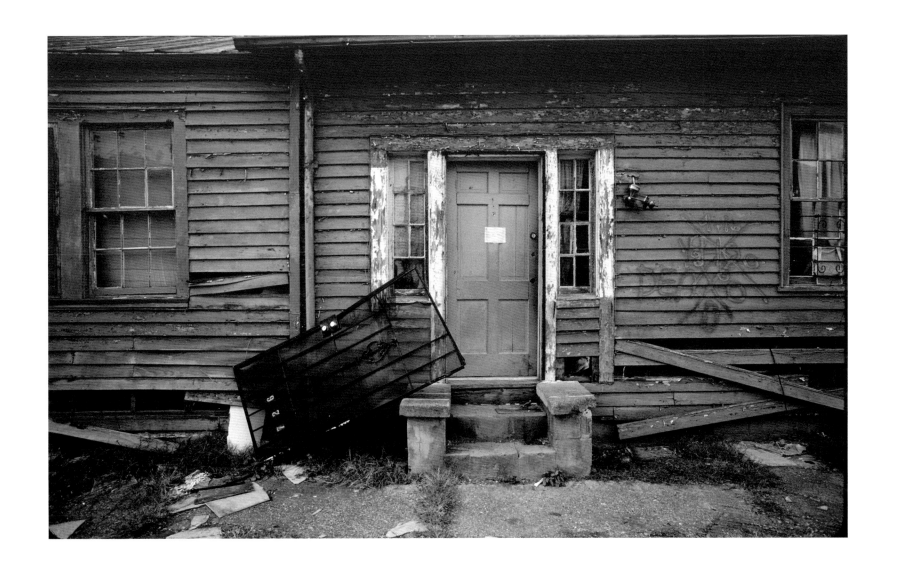

IAN J. COHN

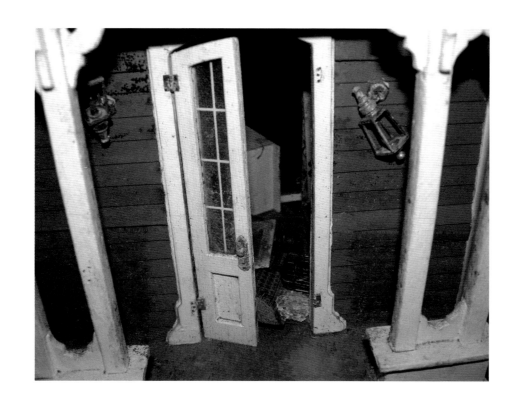

KATHY CACIOPPO

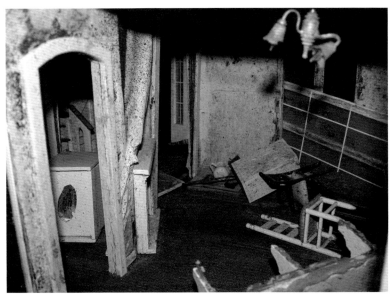

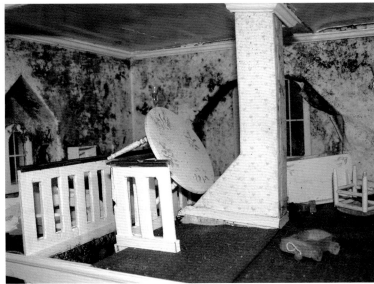

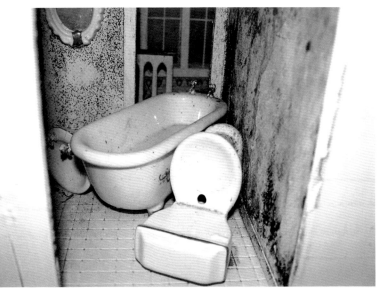

KATHY CACIOPPO

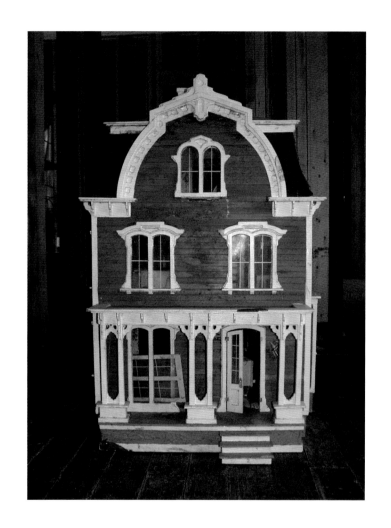
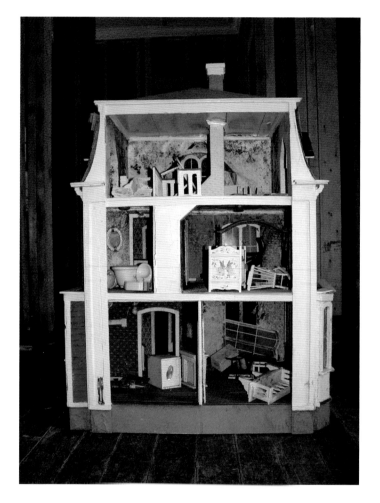

KATHY CACIOPPO

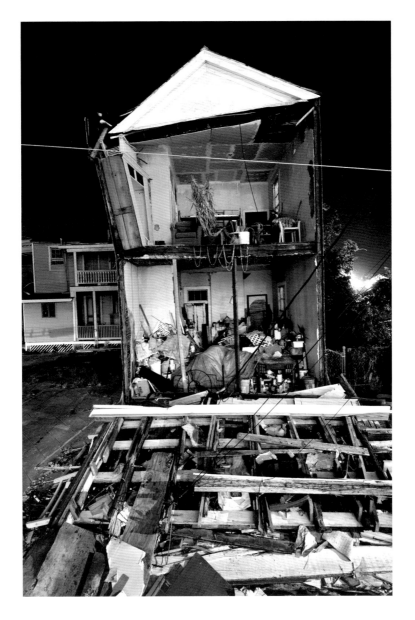

JACKSON HILL

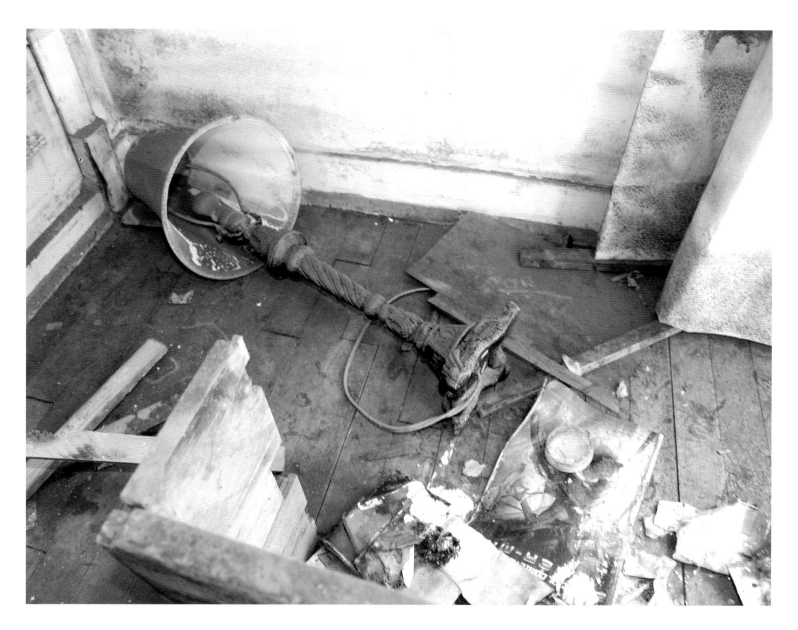

LESLIE KILLIAN

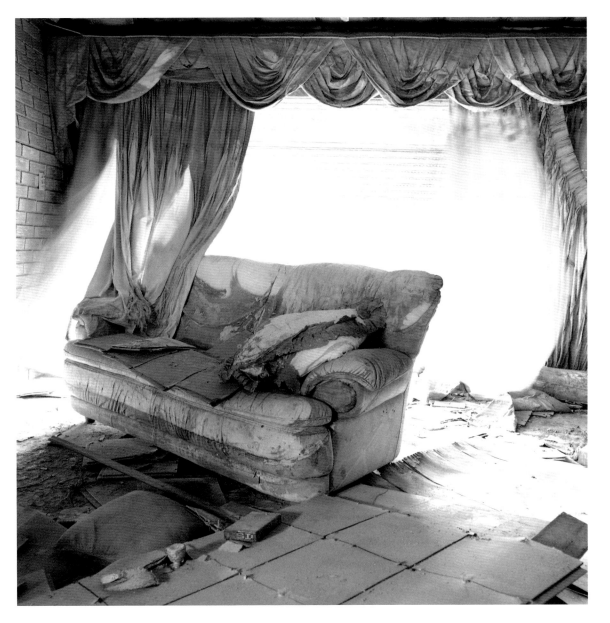

TABITHA SOREN

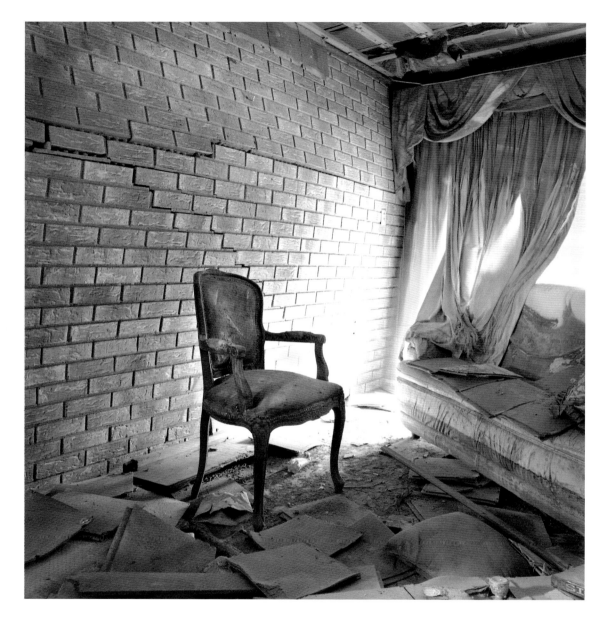

TABITHA SOREN

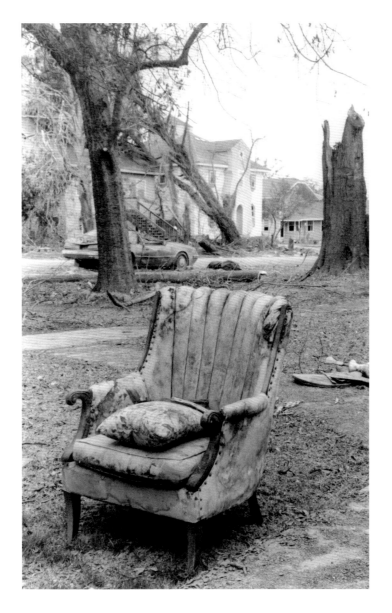

MARY LAIGAST

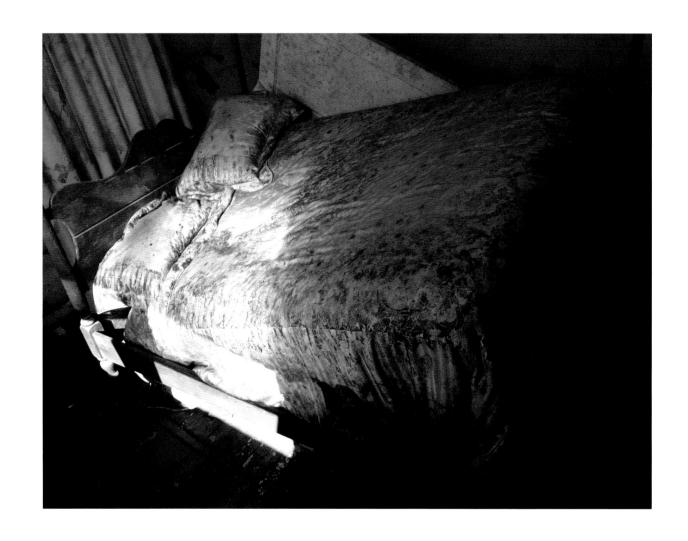

LESLIE KILLIAN

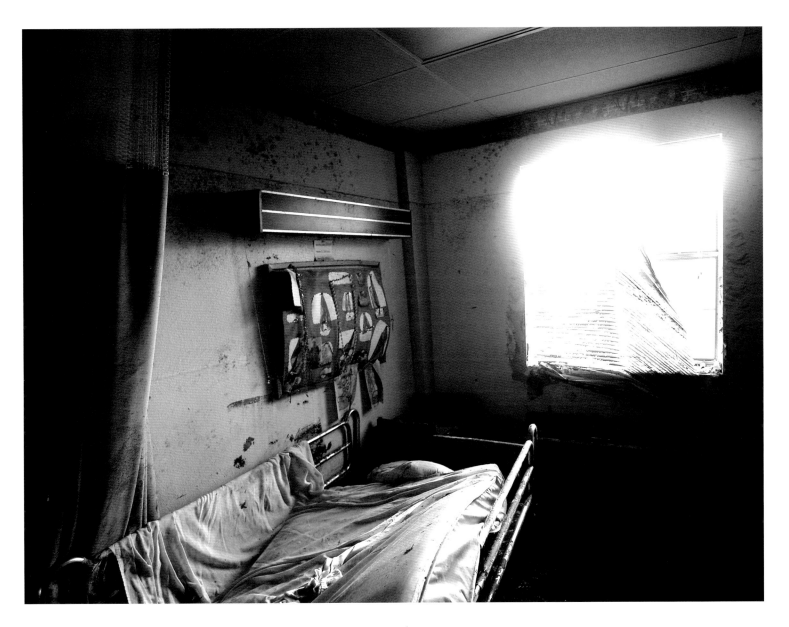

©PAOLO PELLEGRIN | MAGNUM PHOTOS

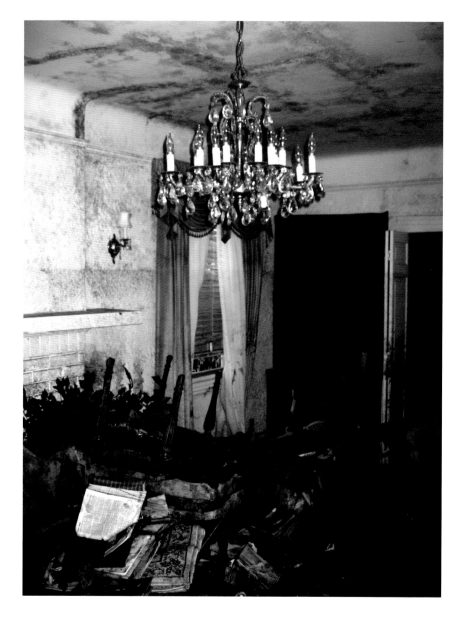

TOM VARISCO

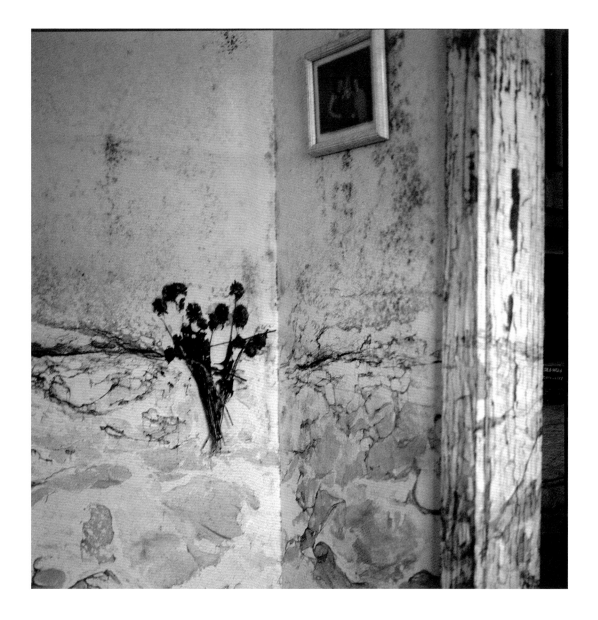

CELESTE MARSHALL

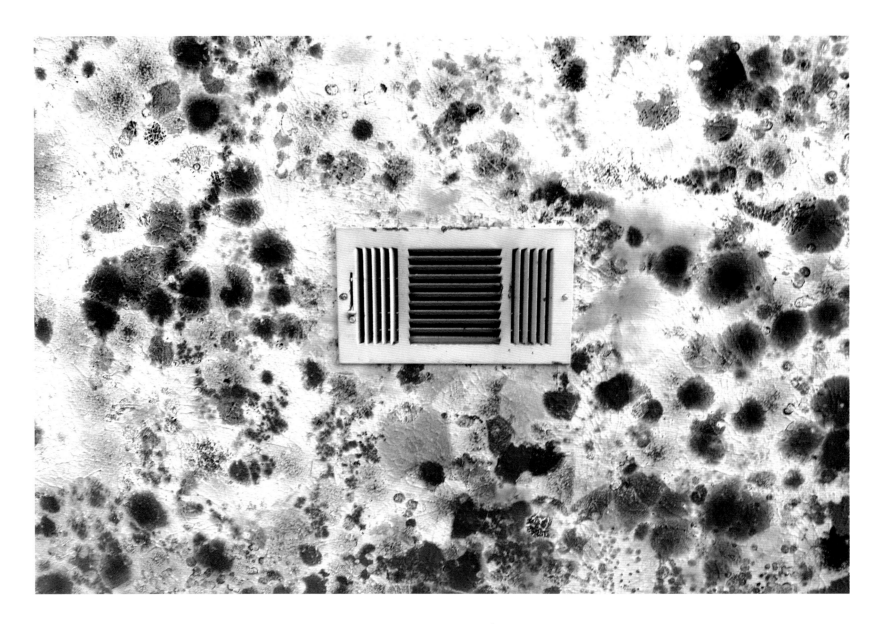

MARIANNA DAY MASSEY | ZUMA PRESS

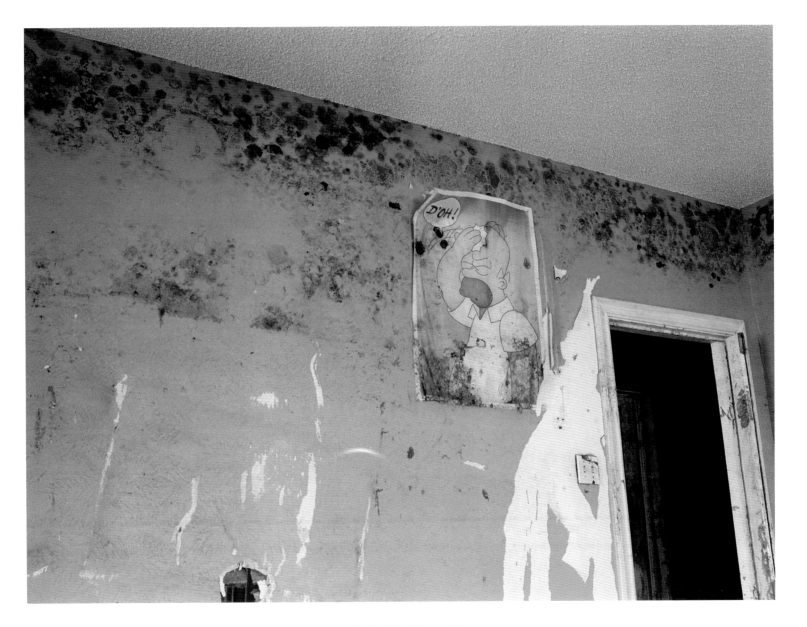

DONNA HURT

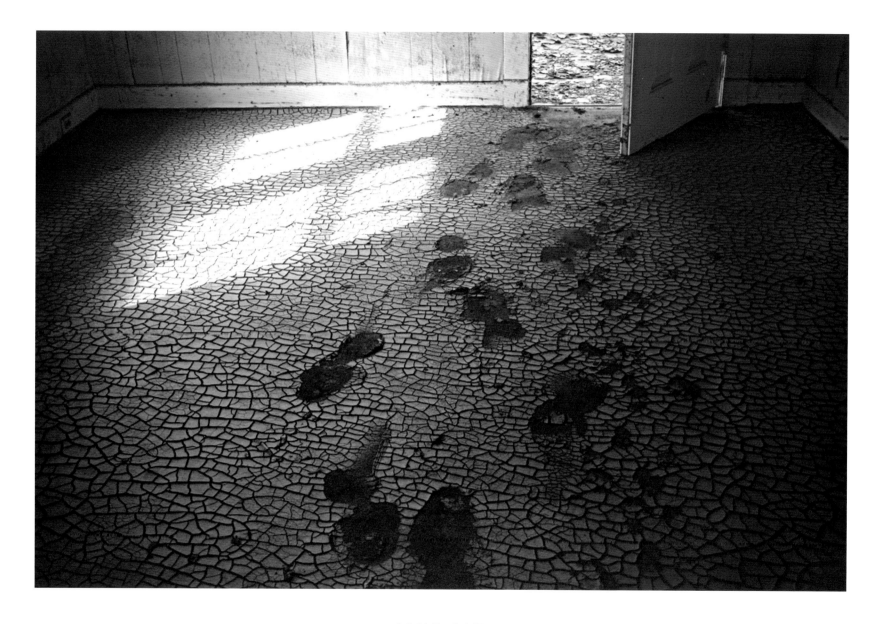

JANE ALT

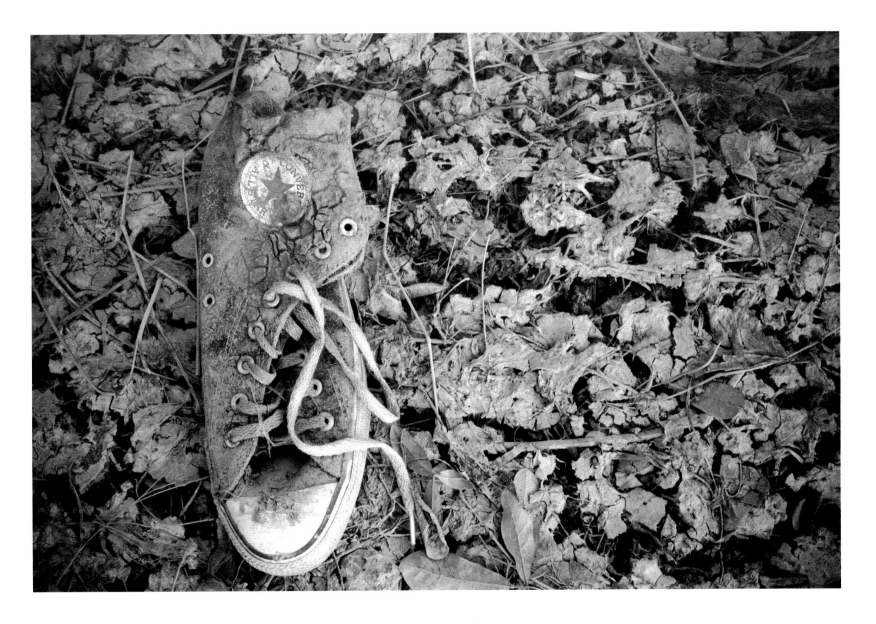

JANE ALT

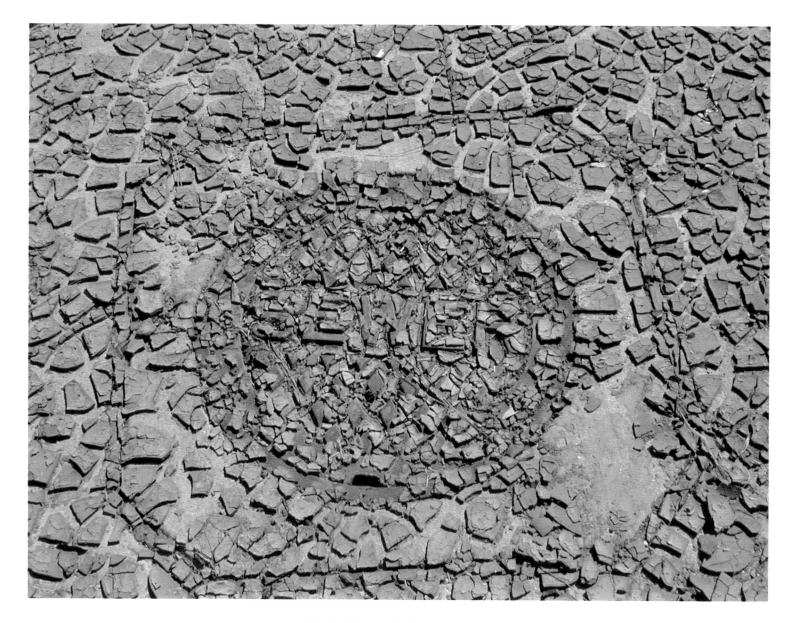

ELLIS JOUBERT III

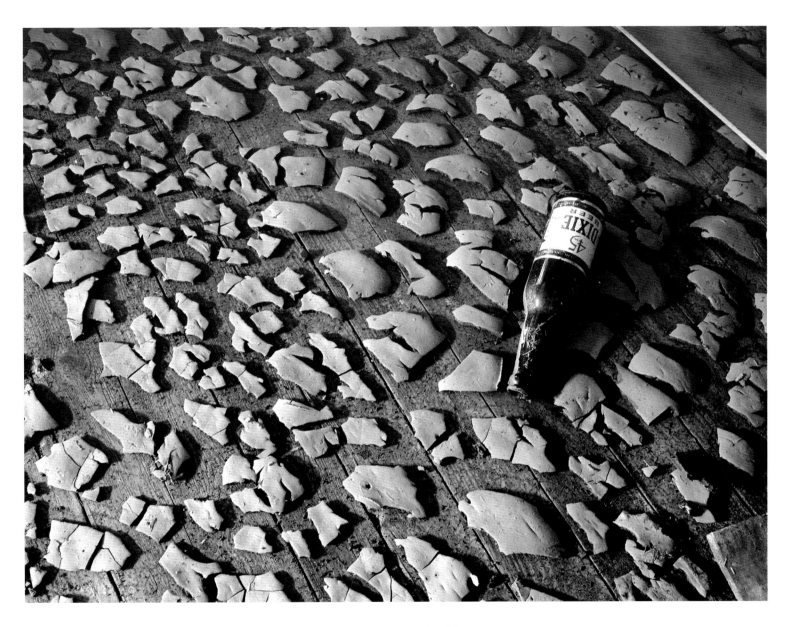

DONNA HURT

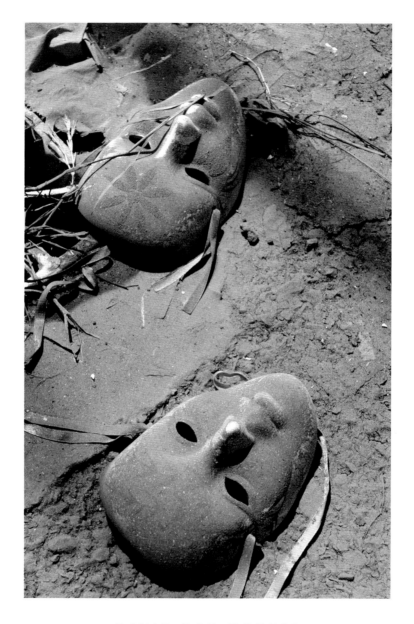

DAVID RAE MORRIS

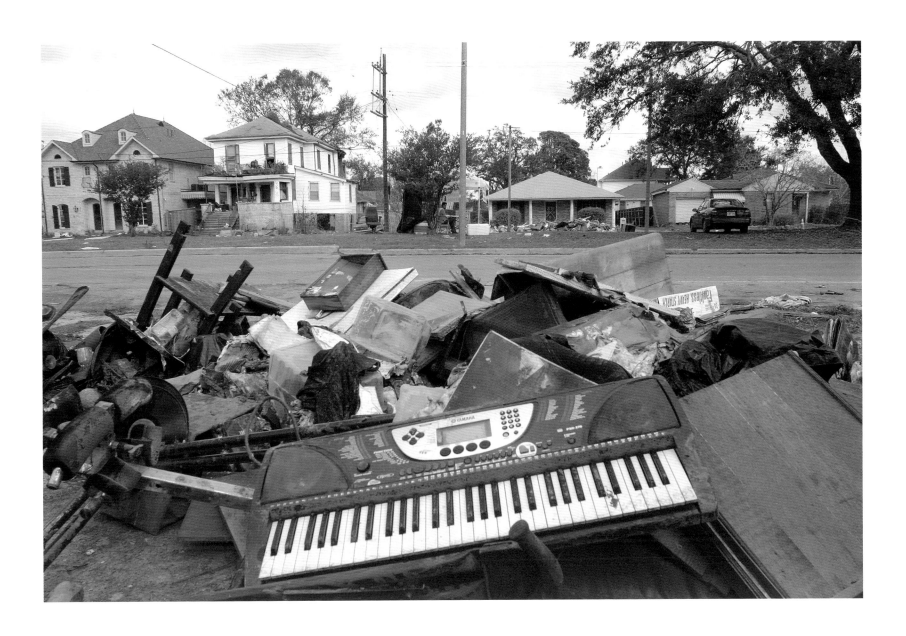

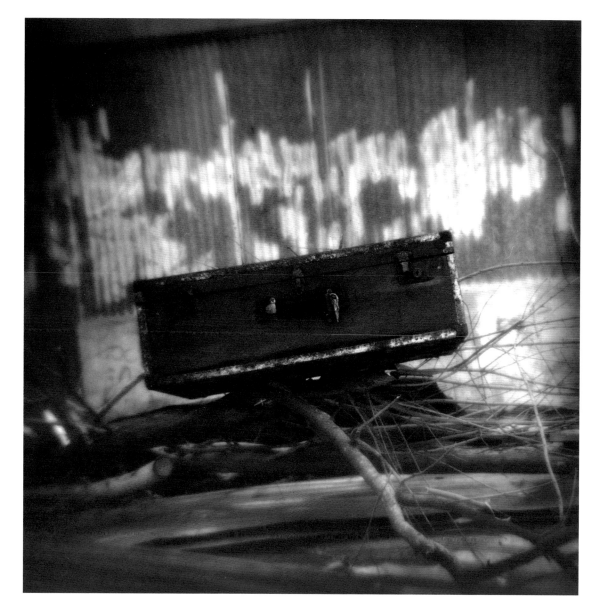

LOUVIERE + VANESSA

142

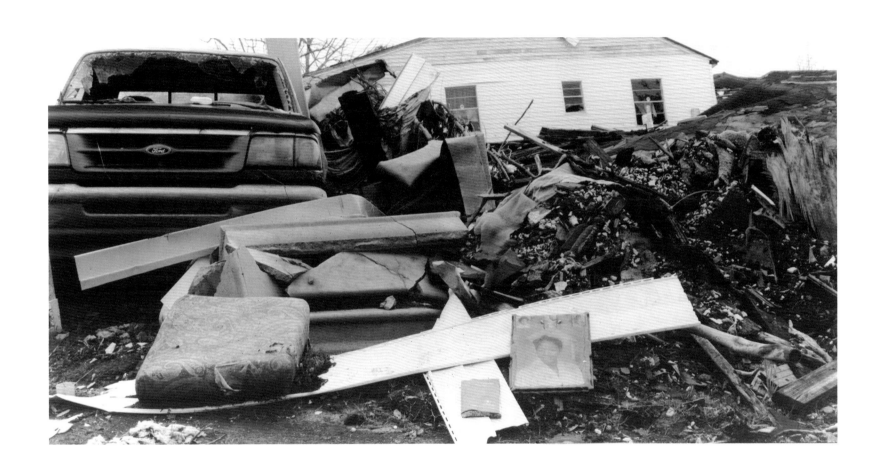

THOM BENNETT

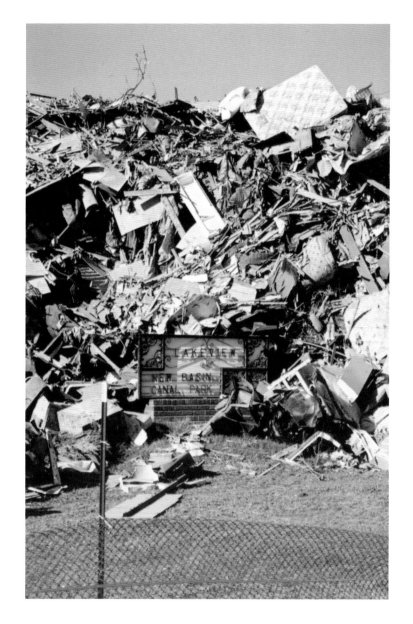
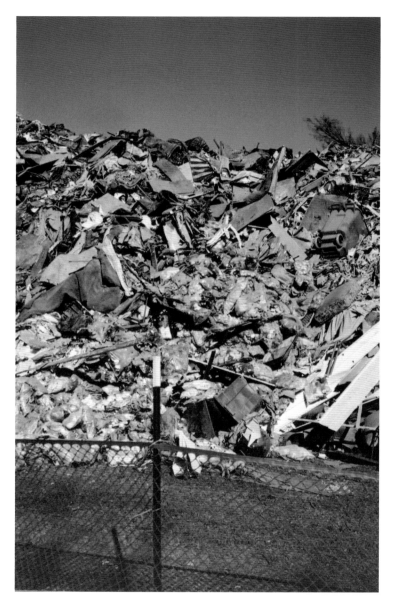

BRIAN SANDS

144

MERYT HARDING

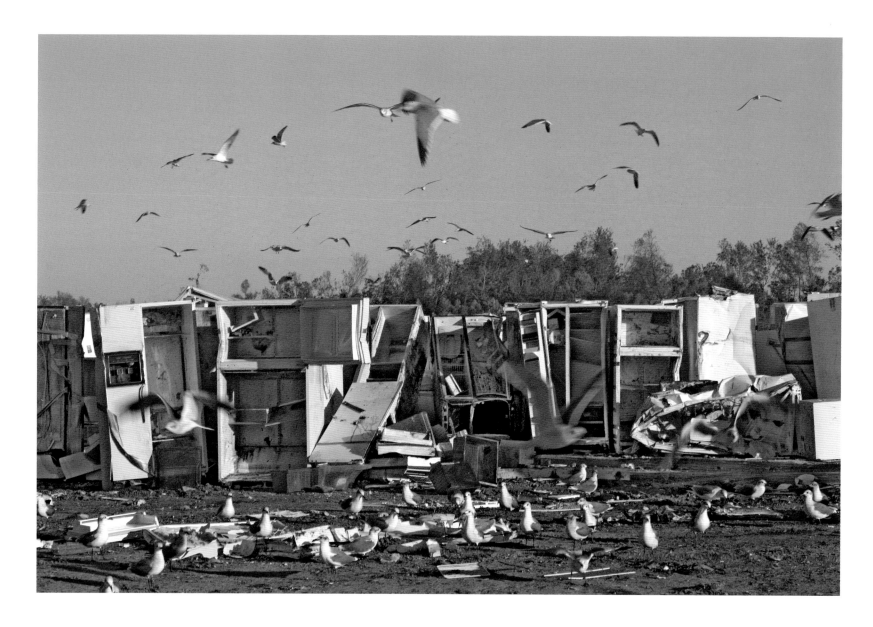

MARK J. SINDLER

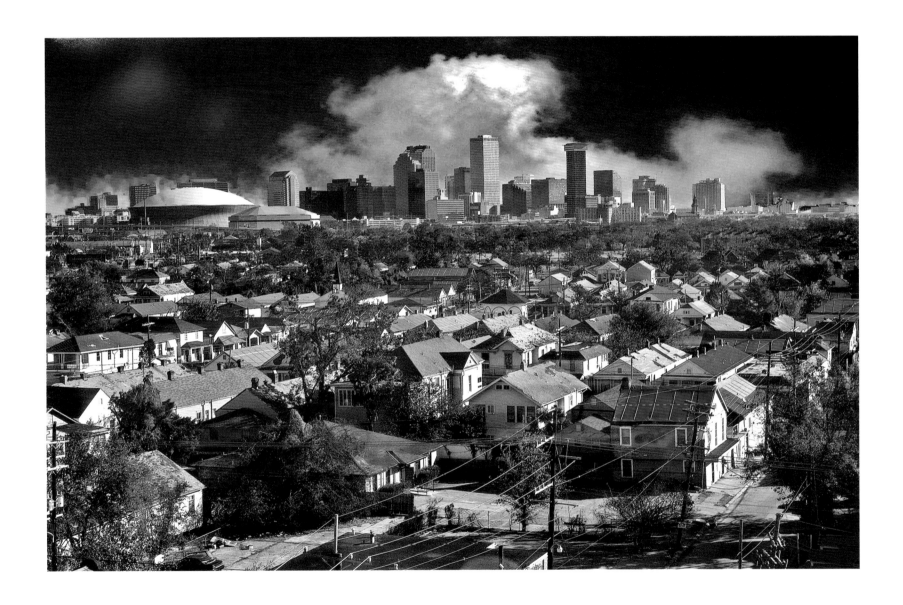

NATHAN KERN

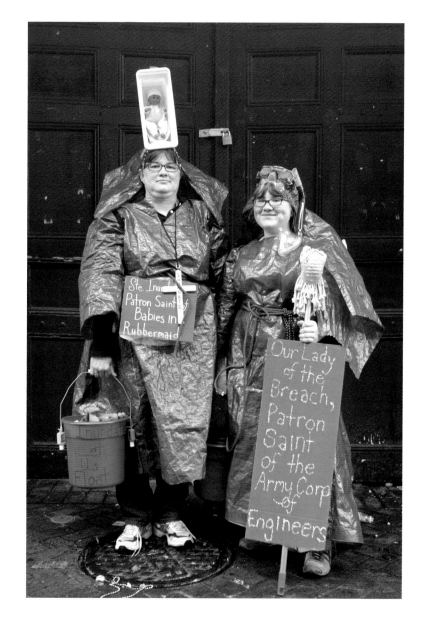

MARK J. SINDLER

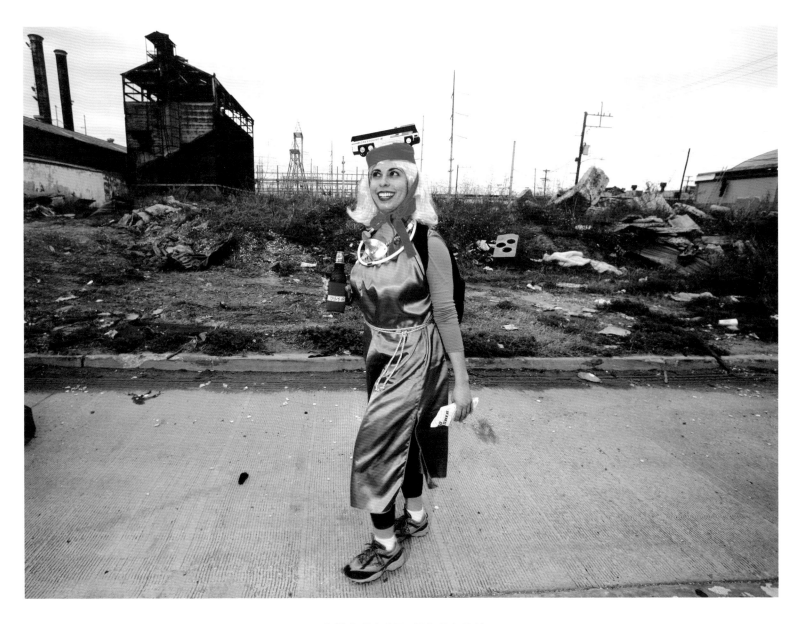

CHARLIE VARLEY

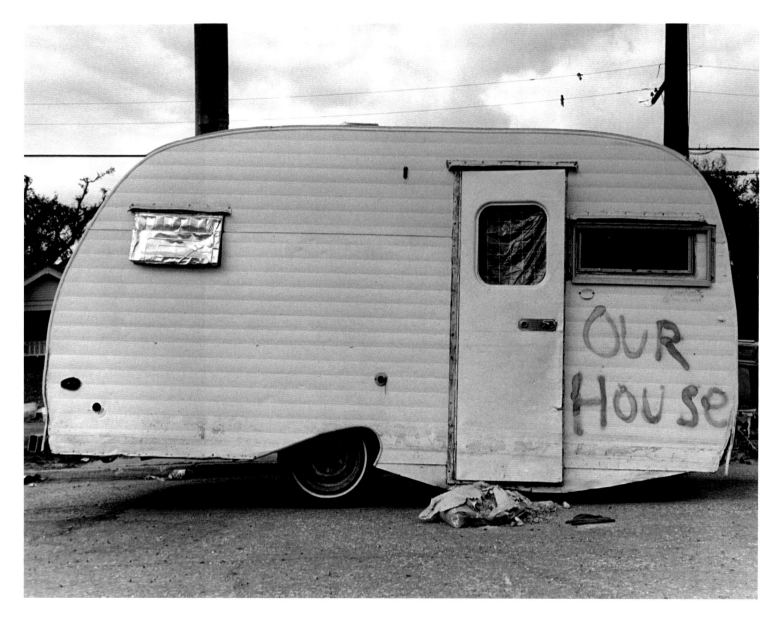

REGGIE SCANLAN

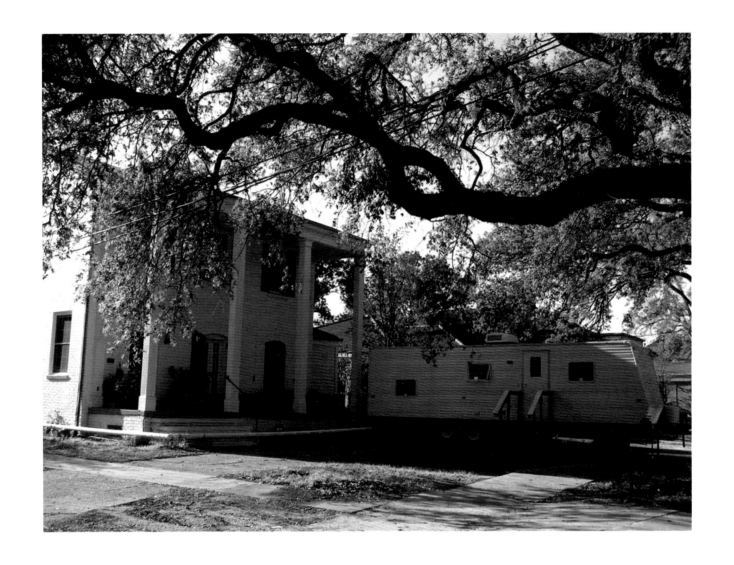

ELIZABETH KLEINVELD

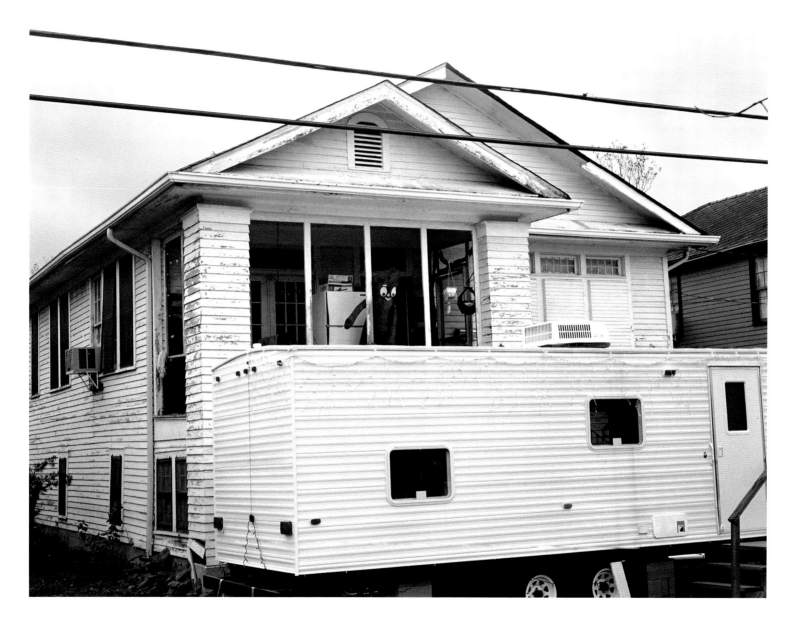

DONNA HURT

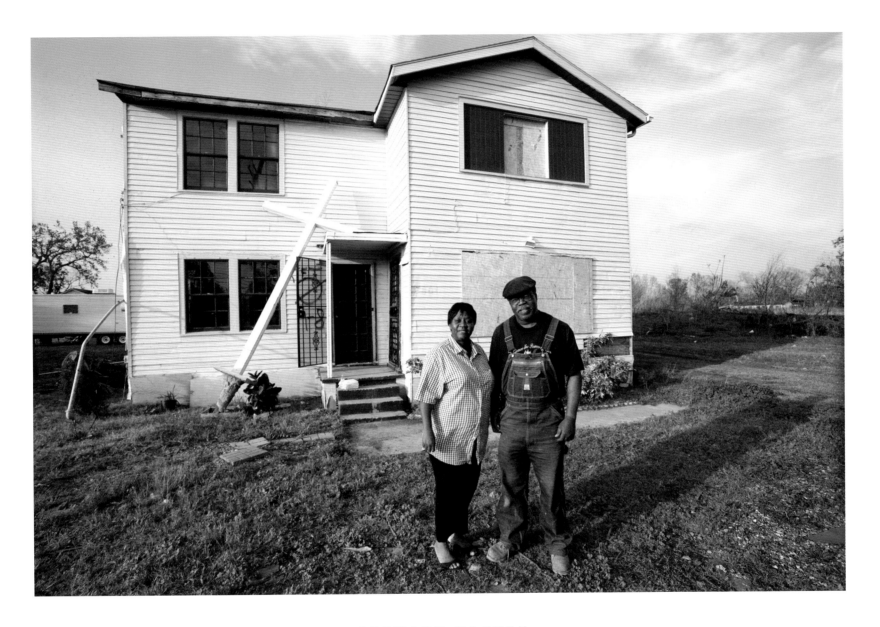

STEWART HARVEY

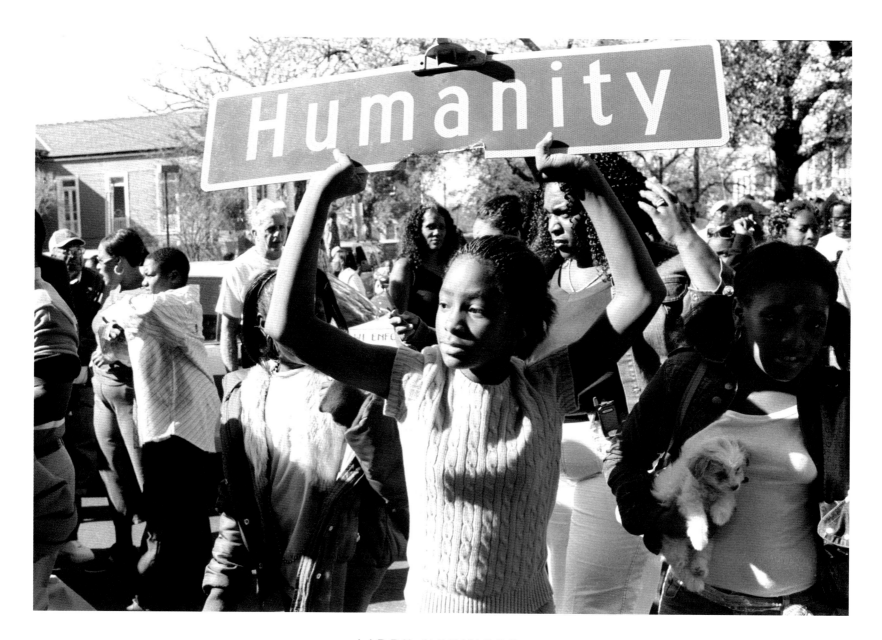

LIBBY NEVINGER

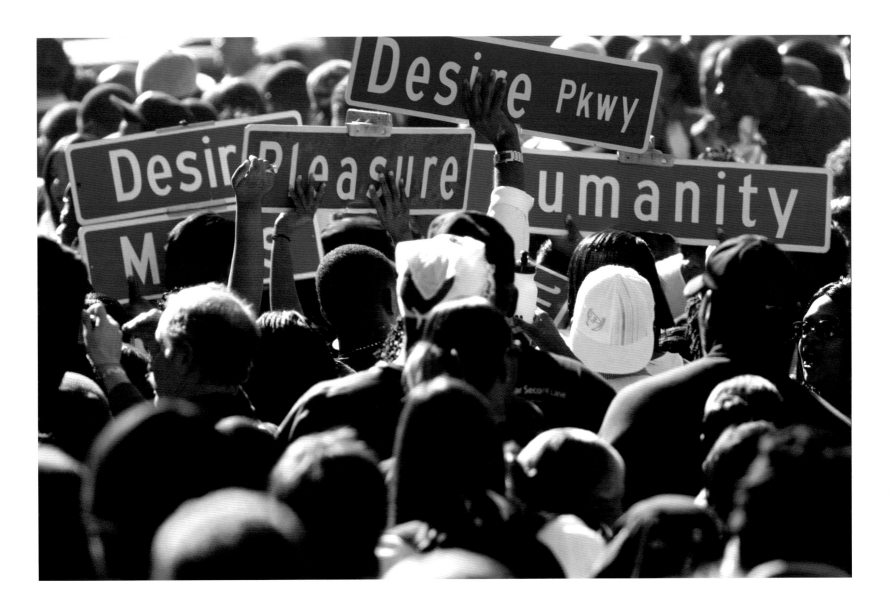

CHARLIE VARLEY

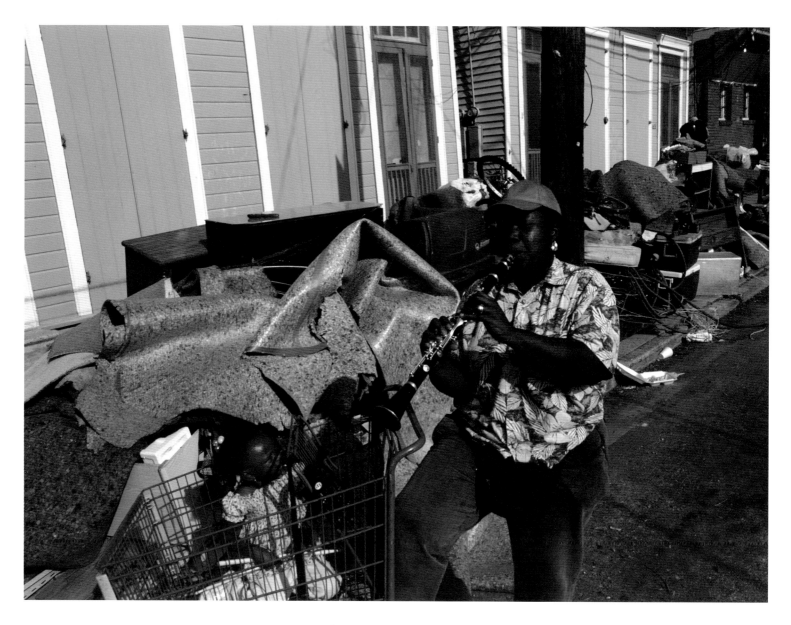

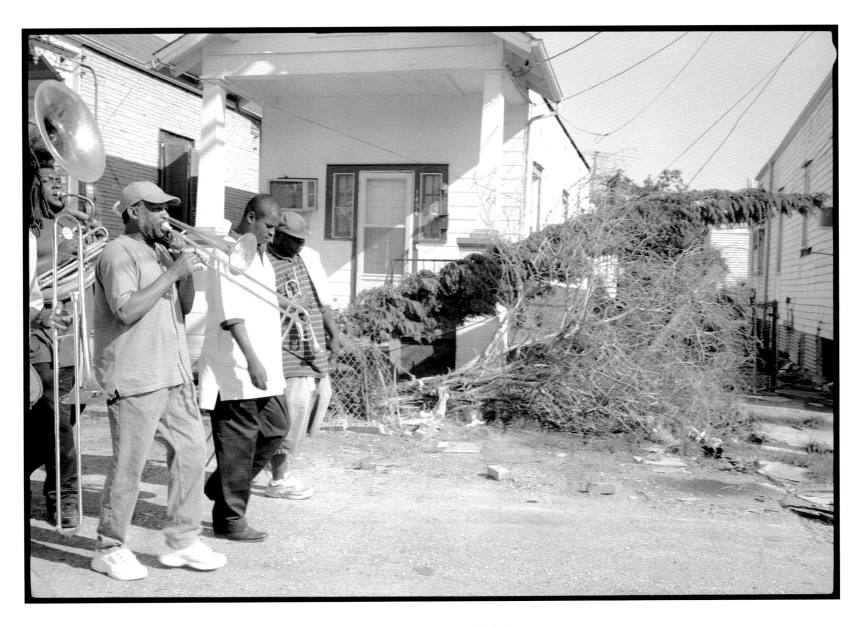

L.J. GOLDSTEIN

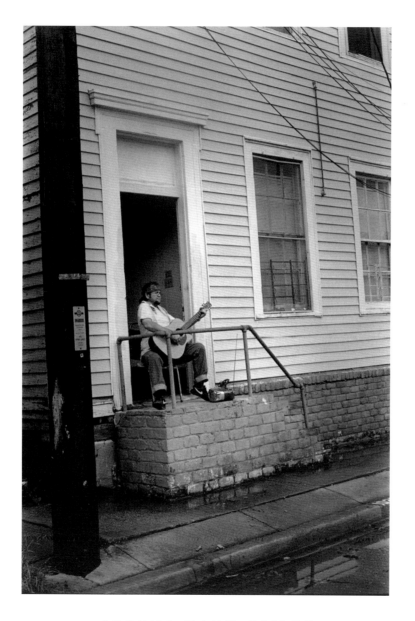

JOSHUA MANN PAILET

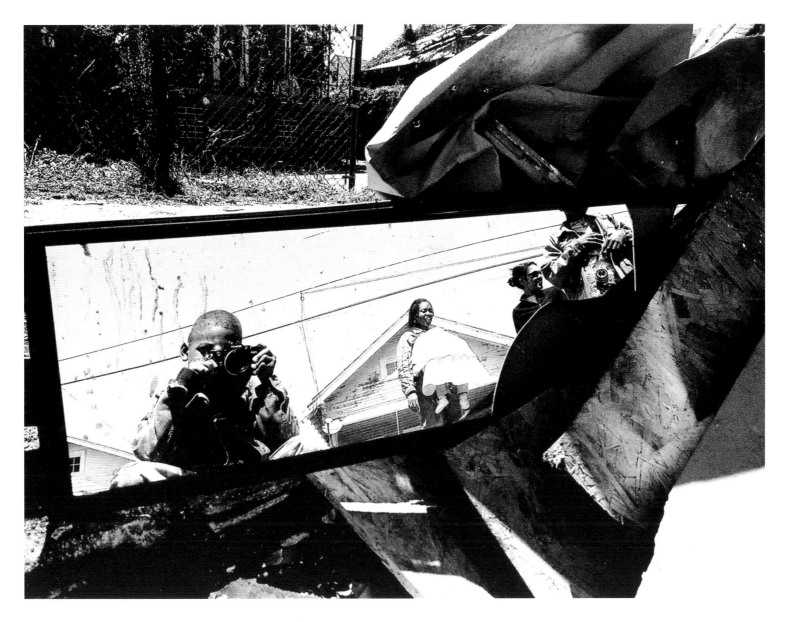

© RAYMOND ROBINSON | THE NEW ORLEANS KID CAMERA PROJECT

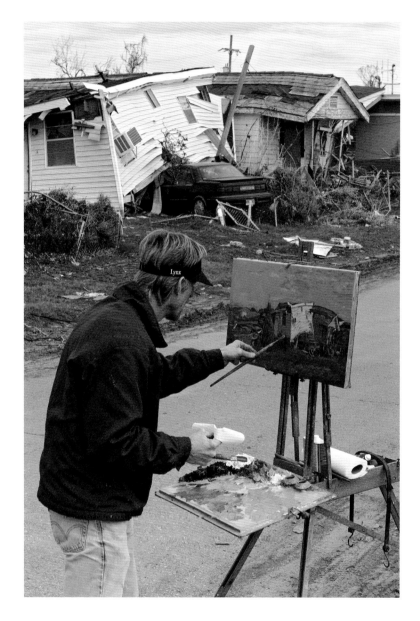

MARK J. SINDLER

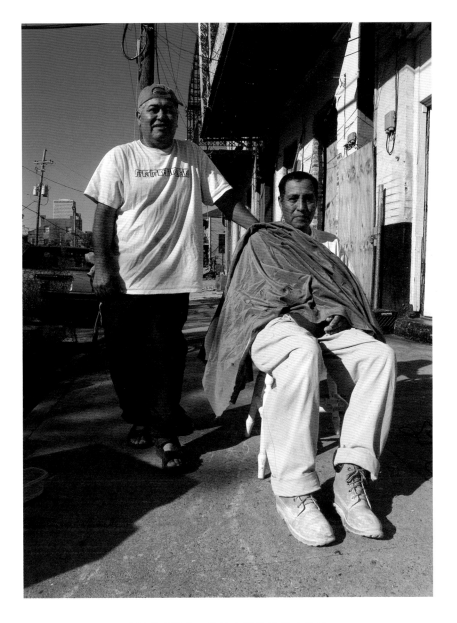

INDIRA CHATTERJEE

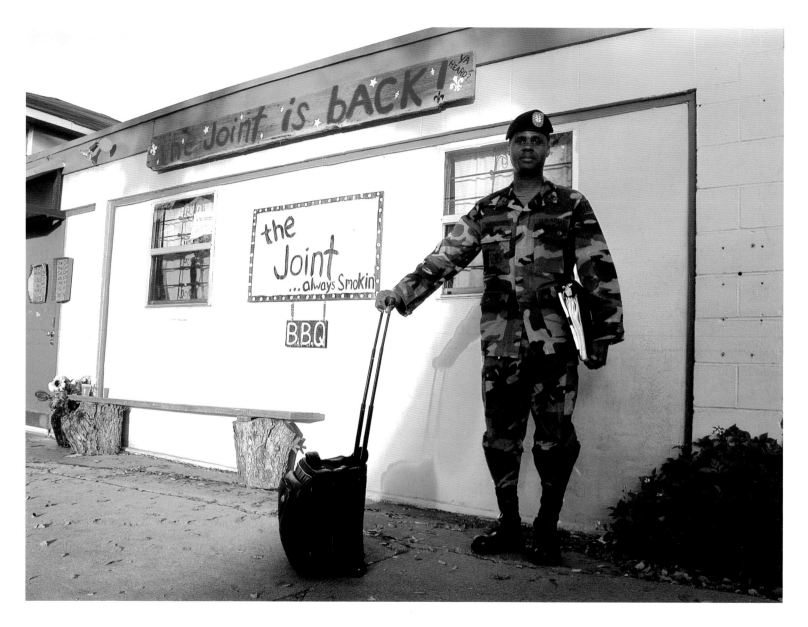

INDIRA CHATTERJEE

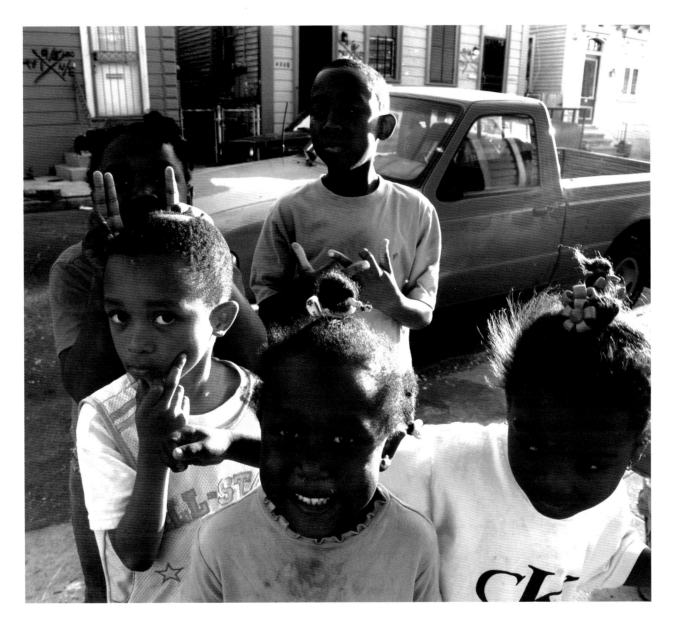

INDIRA CHATTERJEE

CONNIE ALLOTTO

New Orleanians have a strengthened sense of what's important: life and family, friendship and compassion, food and water, and maybe a blue plastic tarp to cover the hole in the roof . But the surprising byproduct of desperation is contemplation; the realization that there is much more to living than simply surviving and that the soul needs sustenance just as desperately as the body. As soon as the storm and immediate crisis passed and the extent of the devastation was revealed, something else was crucially apparent: art and culture are not luxuries, but necessities—sources of solace, comfort, perspective, inspiration, and rejuvenation.

This is why the New Orleans Museum of Art needs your assistance. NOMA weathered the hurricane on its own, but now to succeed in its aftermath, we need your help. Millions of dollars are needed for recovery—to rehire all our staff, to rehabilitate our building, to rejuvenate our exhibitions and education programs— to get us back to where we were before the storm. And millions of dollars are also needed for advancement and change—to respond to the new needs of our community and to bring us forward as the premier arts institution of the new New Orleans.

We appeal not only to the people of New Orleans, but to the national and international community of artists, art lovers, cultural institutions, and their generous benefactors. Please help us to achieve our shared ambition: to promote and celebrate creativity and imagination, and to respond to the hunger of our audiences to see, to cherish, to learn, to think, and to feel.

New Orleans Museum of Art
P.O. Box 19123
New Orleans, Louisiana 70179
(504) 658-4100
www.noma.org